EMPIRE

10 YEAR
ANNIVERSARY

Cofounders: Taj Forer and Michael Itkoff

Book editing and design: Martin Hyers, William Mebane, and Ursula Damm

Copyediting: Laura Fredrickson

This first edition of *Empire* is limited to 1,000 copies.
Empire is published in conjunction with the Museum of Contemporary Photography,
Columbia College Chicago.

ISBN 978-0-9889831-8-2

Printed in China

Daylight Books

E-mail: info@daylightbooks.org

Web: www.daylightbooks.org

EMPIRE

Martin Hyers and William Mebane

Daylight

ACKNOWLEDGEMENTS

For their continued patience and support, we offer our sincere thanks to our families. We would like to thank our wives, Andrea Gentl and Martha Corcoran, without whom this book would not have been possible. And to our parents—Dee and Kemper Hyers, and Bern and Cathy Mebane—who instilled in us a deep appreciation of the power of objects and their potential to carry stories. Our siblings and our children deserve a special thanks: Kemper Hyers, Campbell Hyers, Lula Hyers, Sam Hyers, Catharine Sturtevant, Janie Mobley, Harriet Mebane, John Mebane, Beverly Helms, Jasper Mebane, and Bern Mebane.

We are grateful for the continued support of Tim Barber at tinyvices.com and Kathy Ryan and her team at *The New York Times Magazine*. Both have previously published selections of these photographs and have been instrumental in sharing our work with a wider audience.

Many thanks to Steven Kasher and his staff at Steven Kasher Gallery, to Amani Olu and Jon Feinstein at Humble Arts, and to Sophie Morner at Capricious Space for bringing this work into their exhibition programs.

Lenka Shirova, Barbara Reiser, and Rob Magnotta offered tremendous support and production assistance throughout the entire process.

We would also like to thank our friends and colleagues who have graciously offered feedback and insight along the way: Nancy Jo Iacoi, Eirik Johnson, Henry Wessel, Linda Connor, Marcia Lippman, Amanda Marchand, Nelson Hancock, Joe Johnson, Lisea Lyons, David Douglas, Richard Barnes, and Paula McCartney.

We would like to thank all of the people who welcomed us into their lives and gave us access to photograph their homes and businesses; this book would not have been possible without their generosity.

We feel blessed to have had the opportunity to develop this project and book with Natasha Egan, Karen Irvine, and the entire Museum of Contemporary Photography staff. Their support has been invaluable. We would especially like to thank Karen Irvine for her thoughtful and generous essay that serves as the foreword to this book.

Museum of Contemporary Photography
Columbia College Chicago

MATERIAL USA Karen Irvine

From 2004 to 2007 Martin Hyers and Will Mebane spent many months traveling across the United States on a picture-finding mission. Their goal was to photograph objects in people's homes and workplaces in order to fashion a time capsule of American material culture. Over many hours of driving America's highways they listened to the audio edition of the book *American Theocracy: The Perils and Politics of Radical Religion, Oil, and Borrowed Money in the 21st Century* (2007), written by former Republican Party strategist Kevin Phillips. Phillips's critique of the US banking system with its structural encouragement of the astronomical accumulation of private and public debt and the looming housing crisis was prescient, and seemed to be revealing itself to the artists while they were out roaming America, meeting strangers, going to their houses and offices, and hearing their stories.

One day while the two photographers were driving, President George Bush's voice came on the radio. He spoke of Americans having "no desire to dominate, no ambitions to empire" at a time when the United States was fighting two wars against two sovereign nations.[1] As Hyers and Mebane listened, they were struck by the disingenuous tone of Bush's comments and their overriding sense that the president was out of touch with the ordinary American. They were inspired to call their project *Empire*, as the multiflorous collection of objects they had recorded represented for the artists "the fruits of our empire—the physical record of our culture. Objects

are not only aspirational, but also a function of what one can afford. The pictures in this project, taken in the aggregate, speak to our view of the values and means of American society."[2]

Empire took Hyers and Mebane to twenty-one states, covered hundreds of miles, and resulted in more than 9,000 sheets of exposed 4 x 5 sheet film. Now 9,000 photographs strong, the collection chronicles a vast array of items, indiscriminately selected—random, commonplace things such as family photographs, Christmas trees, menorahs, pacifiers, clocks, trophies, rugs, television sets, ceiling fans, vibrators, board games, and on and on. The images exist primarily on a website at www.empirearchive.com but also as film negatives, sets of paper prints, and now as the collection of images in this book. Hyers and Mebane have deliberately created physical manifestations of the project, partly for practical reasons like exhibitions and sales, but also to ensure that the images will exist in case the digital records are not properly migrated onto perpetually newer technologies and rendered inaccessible.

Taking inspiration from the tradition of the American road trip in photography by practitioners such as Joel Sternfeld and Stephen Shore, Hyers and Mebane wanted to take the pulse of contemporary American culture and the ways in which material objects and the physical environment reveal it to us. Their method was simple: they met strangers in stores, on streets, or in other locations and

asked permission to enter their homes and businesses and photograph the objects inside. Using two cameras, the pair took pictures with what they describe as a "Weegee-style setup," meaning a 4 x 5 format handheld film camera with an on-camera flash. The artists were methodical about shooting from a distance of three feet, which together with the camera setup helps guarantee consistent lighting conditions and an undeviating style. It also creates an aesthetic that harkens back to the history of crime photography, early press, and paparazzi photography. By suggesting evidence and importance, the artists' technique also engenders a sense of neutrality and veracity.

Although the technique suggests democracy, it actually records the personal choices of the two artists—the locations and subjects they preferred. And of course, for Hyers and Mebane, much of the joy of the project was found in the process of traveling, choosing the specific locations, and meeting the people who owned the particular objects they photographed—something only the two of them were able to experience, but we certainly can imagine. A major source of delight was the openness and generosity of strangers. One of the most memorable experiences they had took place in Charleston, South Carolina:

A woman had let us into her small two-bedroom apartment to photograph and her young son helped us carry the film backs. The whole process only took a few minutes. We worked simultaneously with two cameras. Flashbulbs were constantly going off, and it was no mystery what we were photographing. A picture of the lamp. A photograph of the photographs stuck with magnets to the face of the refrigerator. A picture of the air conditioner. A picture of the family photographs on the bedside table. The contents of the closet. What was under the bed. When we were finished, this very proud, yet humble woman asked us, "So how am I doing?"[3]

In their book *The Meaning of Things: Domestic Symbols and the Self*, Mihaly Csikszentmihalyi and Eugene Rochberg-Halton point out that "a home is much more than a shelter; it is a world in which a person can create a material environment that embodies what he or she considers significant. In this sense the home becomes the most powerful sign of the self of the inhabitant who dwells within."[4] They also discovered that objects, in addition to being symbols of status and one's place in the social network, provide a much-needed continuity of the self through time.[5] For Hyers and Mebane, the process of collecting individual stories was inspiring and affecting. In one instance, they photographed a bedroom that appeared to belong to a young boy. A pillow inscribed "Brad" was on the neatly made bed. While photographing, they learned from his mother that Brad had been killed at twenty-five years old in a plane crash, and she had since returned the room to the condition of his childhood. Through all of these individual stories Hyers and Mebane discovered that the emotion and meaning we connect to objects are only

sometimes available for others to appreciate. And, over time, the two artists became increasingly convinced that the aggregate of all of the stories painted a unique, yet uncannily familiar and pertinent portrayal of American culture.

Although the *Empire* archive will help us remember, as the years pass its images will also lose their familiarity. Already one is struck by a lack of certain objects that have become standard in many American homes today: smartphones, flat screens, tablets, Xboxes, for example. Funny to think that the things that have become so widely integrated into our lives were not there, or were at least extremely rare, just five or six years ago. And where will we be ten years from now? Will board games be completely replaced by electronic versions? Will electrical equipment still require cords and plugs? Will laptops and typing seem archaic? As the archive ages, the photographs will undoubtedly attest to many varied changes, both overt and subtle, in American culture.

While making the *Empire* pictures, Hyers and Mebane became fascinated with vernacular American architecture and how its myriad styles and motifs reflect the melting pot of the United States. In 2009, the artists began to document homes as a logical next step to the *Empire* pictures, to provide context for the objects. They mounted a strobe onto the roof of their car and drove through fifteen states, photographing approximately 1,800 single-family homes. Using

the same camera and flash as they did in *Empire* allowed them to connect the two projects, and to create pictures of houses that are wonky in their sense of scale, and suggest models or dollhouses. Interestingly, the pair started the project in Levittown, New York, a planned community of single-family homes developed after World War II to provide affordable housing to veterans and their families. Levittown became known for the assembly-line manner in which the homes there were produced and the fact that each home came with the identical white picket fence, green lawn, and up-to-date kitchen stocked with modern appliances. Meticulously planned and intended to have a uniform architectural style, Levittown began with a homogenous look, but sixty-five years later that characteristic only amplifies each tiny modification made there.

Hyers and Mebane also extended their work recording homes with the car-mounted strobe to record various locations throughout Brooklyn, the borough in which both artists work and Mebane lives. Their pictures capture the quirkiness of American architecture, as homes are often built with elements appropriated from almost anywhere, with details that are chopped, modified, tweaked, and riffed on from other sources. Their straight-on view and uniform distance from the structures recalls the typological and formal strategies of influences that include Bernd and Hilla Becher, Ed Ruscha, Henry Wessel, and real estate listings, as Hyers and Mebane continue their explo-

ration of the so-called average American and the associated quest for The American Dream. From homes the pair expanded their interests to Las Vegas, cars, zoos, and finally *Here*, a collection of images of retail stores, downtowns, restaurants, roads, overpasses, and other places where life takes place in public, revealing that despite the fact that the United States has become more corporate and standardized in its building styles and practices, the downtown area of many small American towns still retains a variety of architectural styles. As with the earlier *Empire* images, among their reasons for shooting these locations was their desire to produce an enduring photographic record of these particular communities and buildings.

Photographs, like objects, circulate and exist in a complex world of changing relationships, viewing circumstances, social constructions, and rituals of display. In each of their renditions of their many projects—online, on exhibit, or in this book—Hyers and Mebane strive to level the playing field among images. To this end they eliminate all titles, captions, and dates, signaling, perhaps, that the familiar, banal nature of the objects actually turns them into symbols of the dynamic cultural forces from which they have emerged. In addition, the frequent use of the grid implies a level of logic, method, and democracy, forcing images to exist in relationship with one another while maintaining their discrete, individual framing. The meaning of these images thus lies mostly in their relationships to one another and the expanse of overarching projects by Hyers and Mebane.

Our ability to freely make associations among individual images unburdened by text also encourages the pleasure of simply looking and pondering without seeking immediate, didactic answers. By presenting the images in an equalized manner, the artists also encourage a connection between the viewer and the objects forged by their familiarity and in some cases, their American-ness. And certainly the context of a book, or an exhibition, confers meaning on these images of cultural artifacts beyond their individual aesthetic value. Sequencing and editing no doubt profoundly influence our experience of the photographs as well, and put us in confrontation with our biases and changing notions of "taste," and bring personal nostalgia to the surface. Ultimately, the artists know that the images can evoke intimate associations, and they want us to use that resonance to feel connections not only to things owned by someone else, but to the strangers themselves. In this act they hope that we not only accept the whole of their work as a record of America, but also that we will recognize our cooperative responsibility for the state of the union.

(Notes)

1 Martin Hyers and Will Mebane, email to the author, September 18, 2013.

2 Ibid.

3 Ibid.

4 Mihaly Csikszentmihalyi and Eugene Rochberg-Halton, *The Meaning of Things: Domestic Symbols and the Self* (Cambridge: Cambridge University Press, 1981), 123.

5 Ibid., 100.

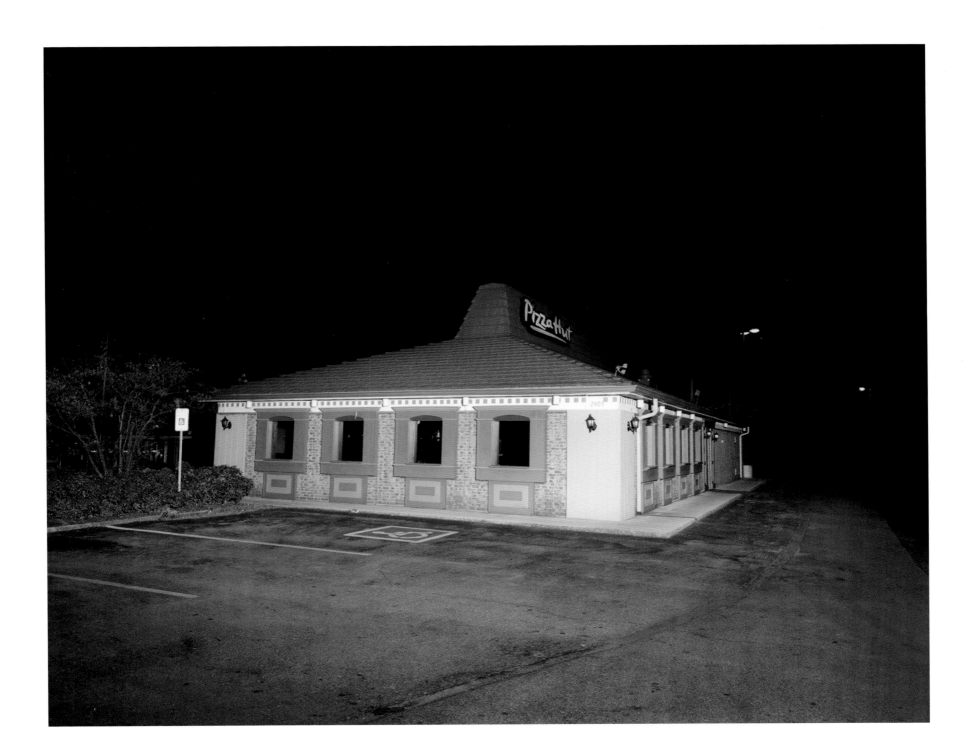

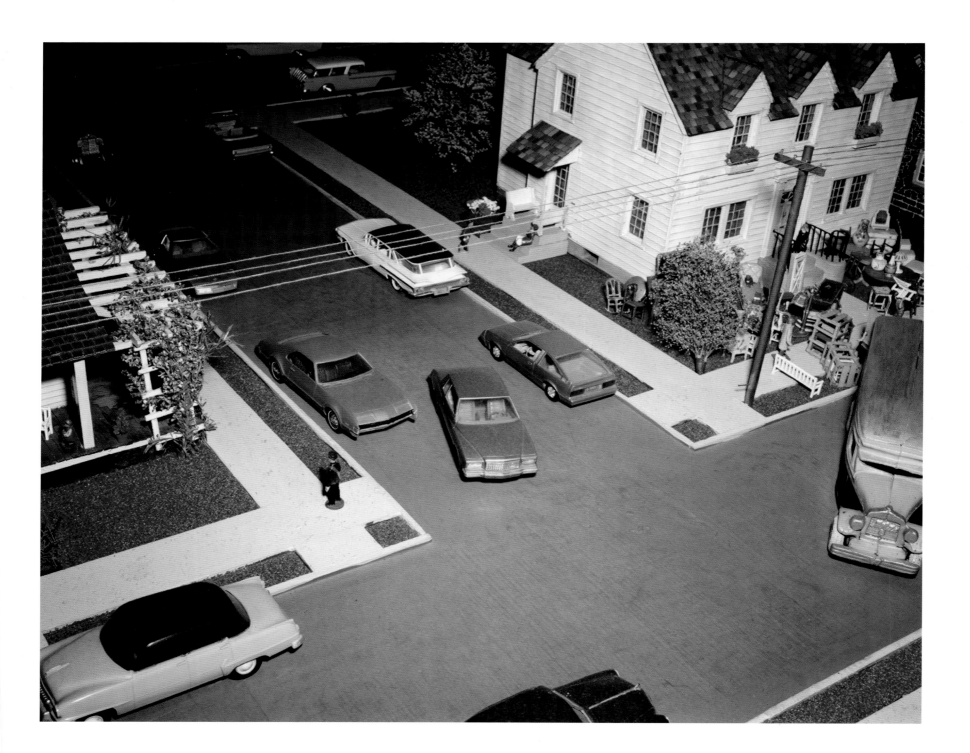

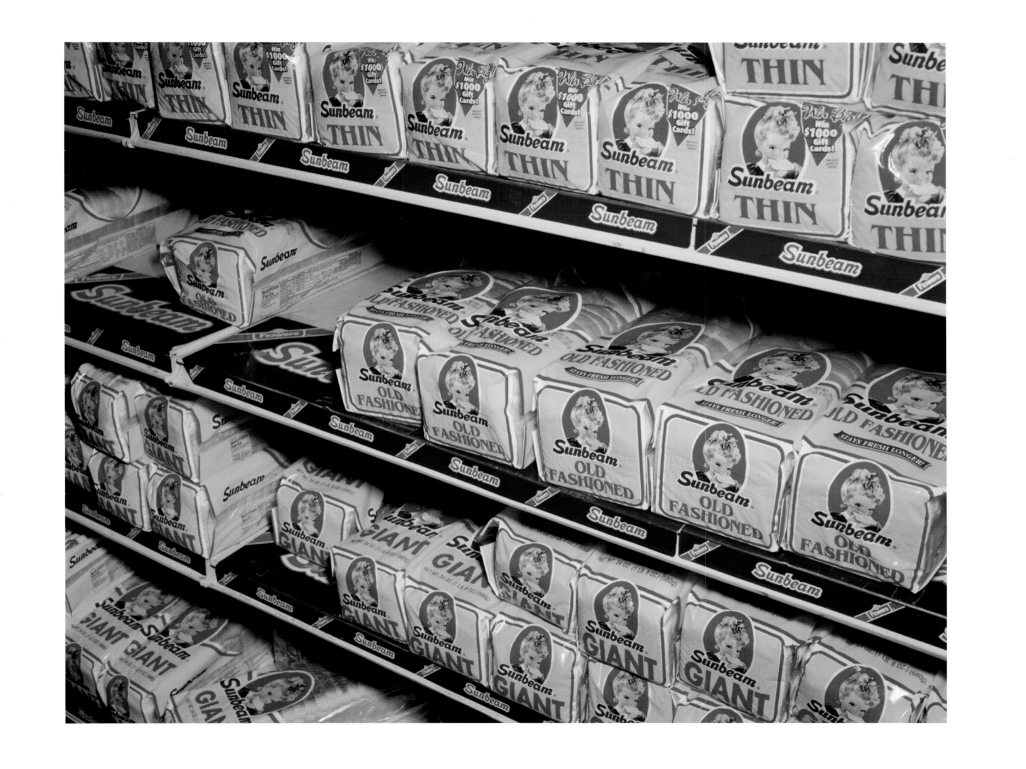

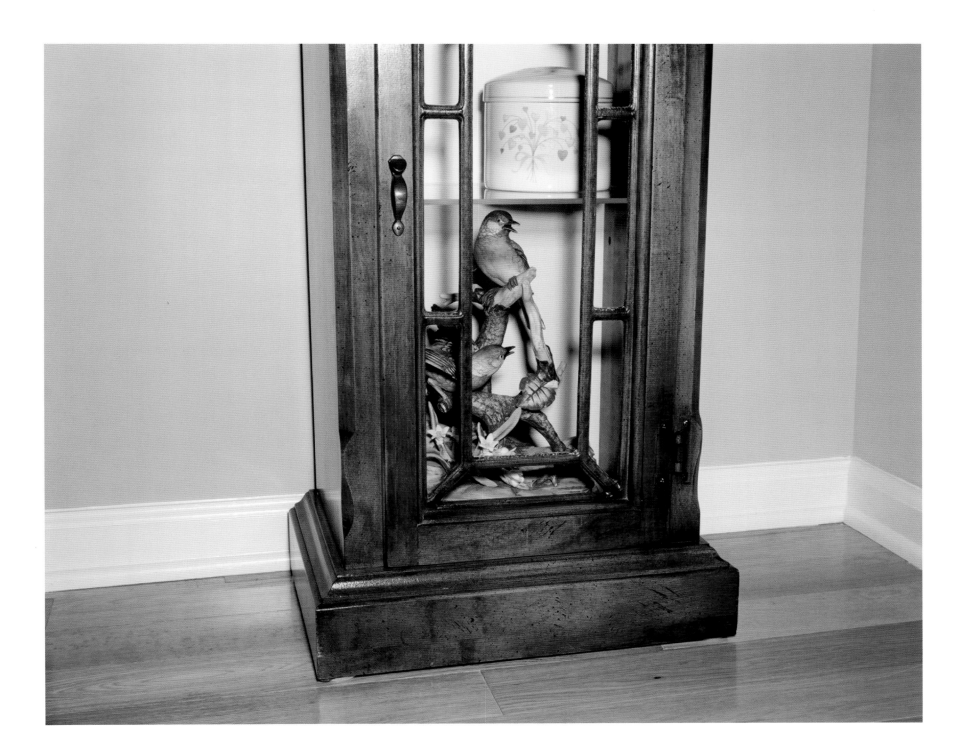

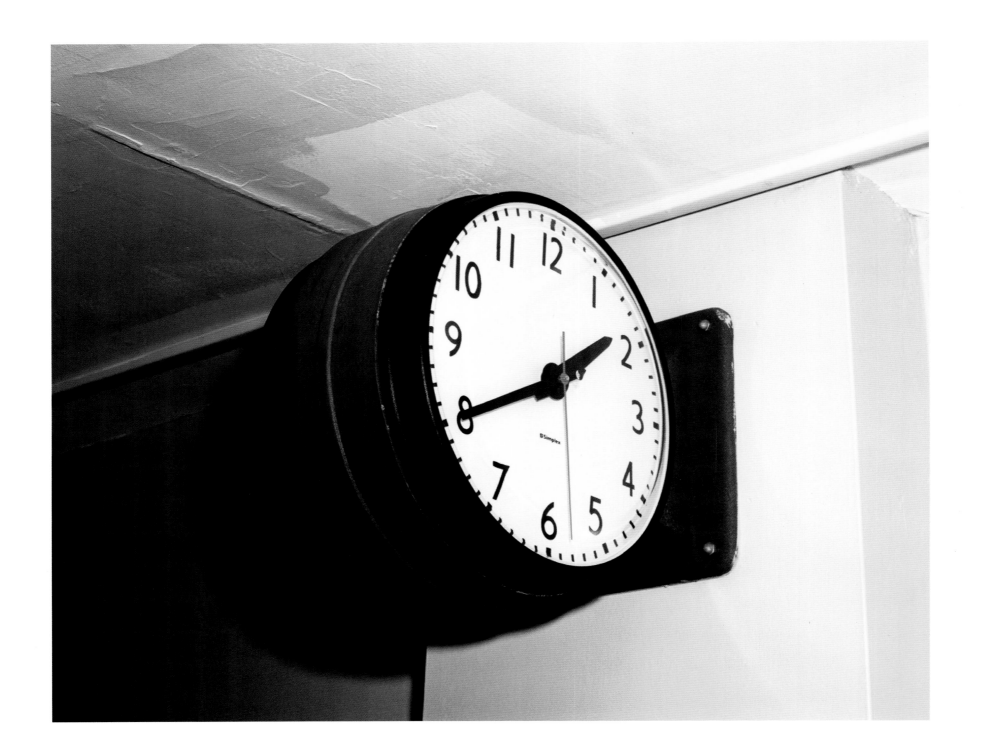

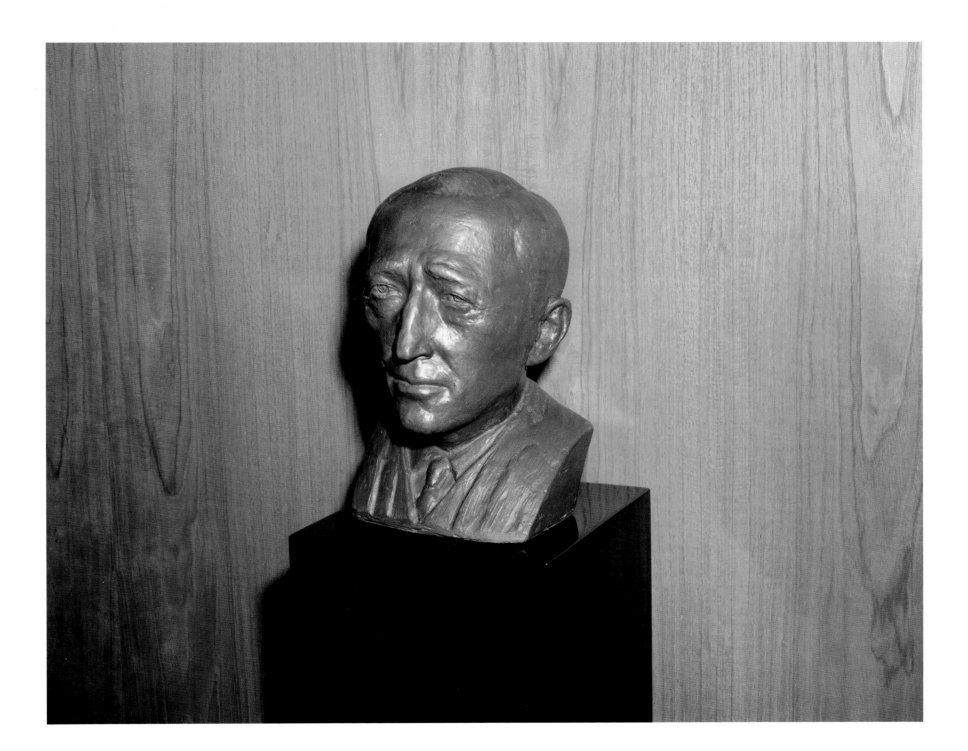

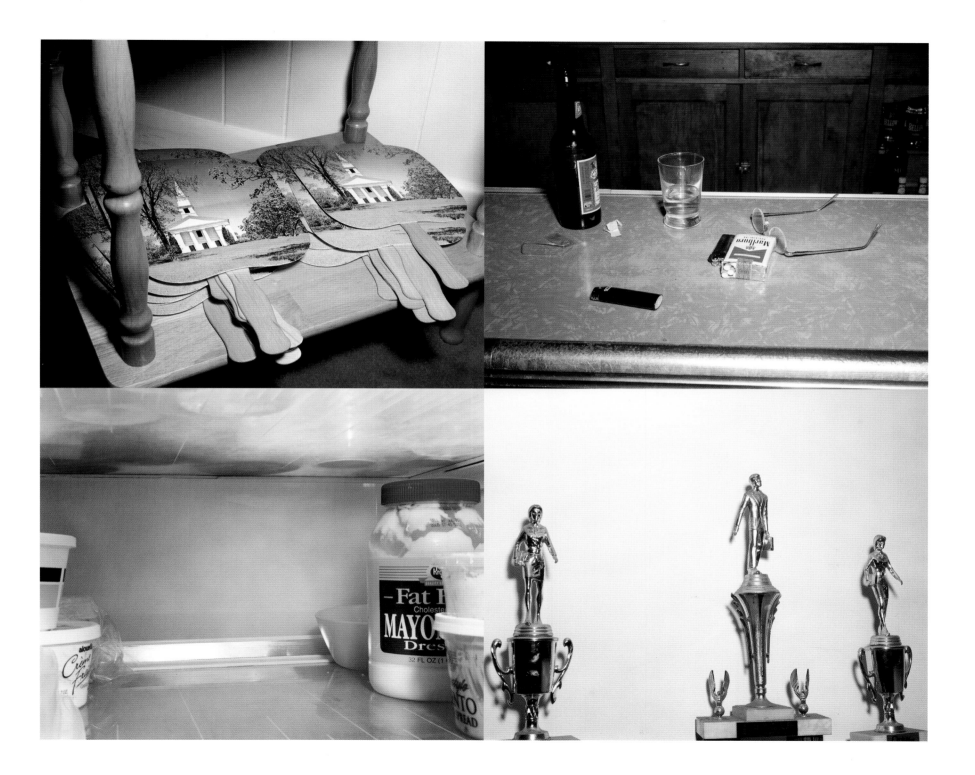

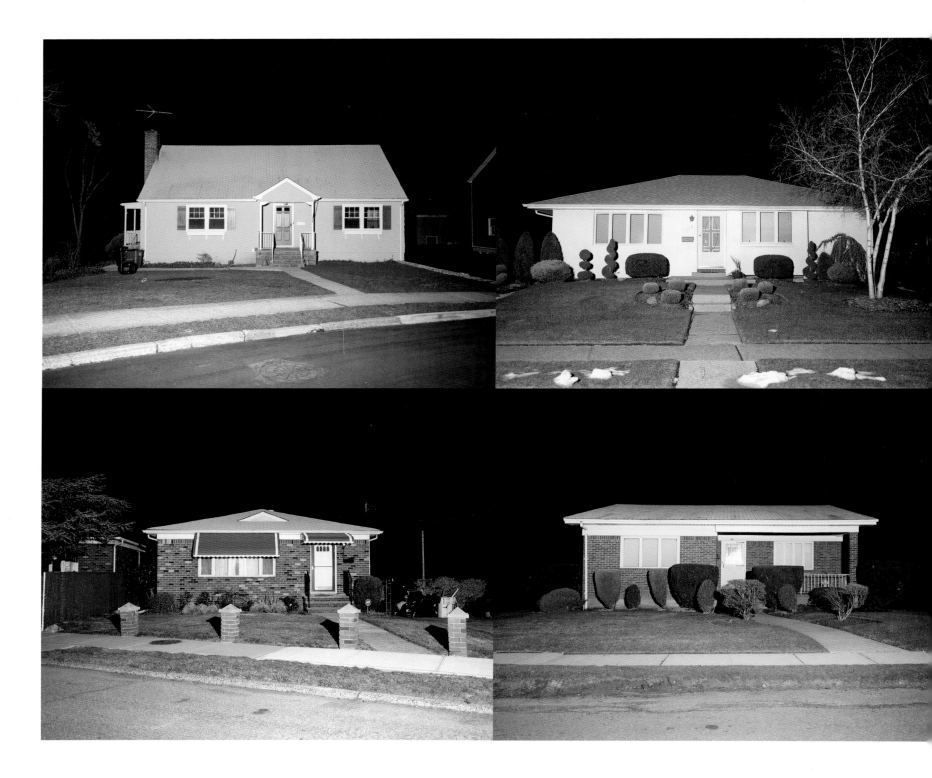

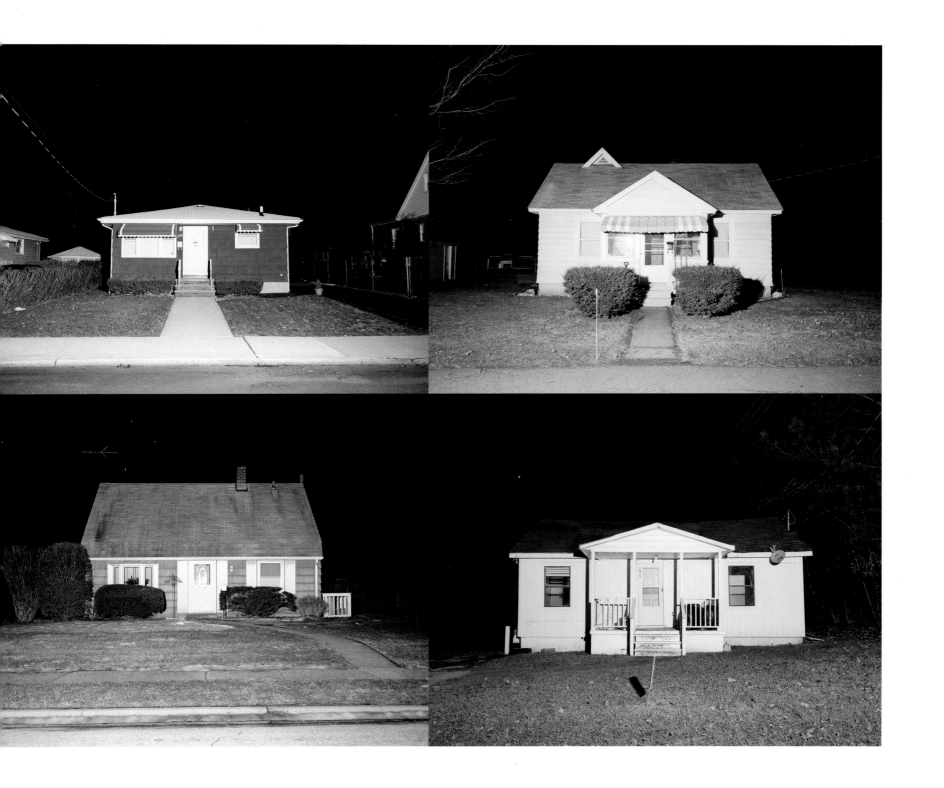

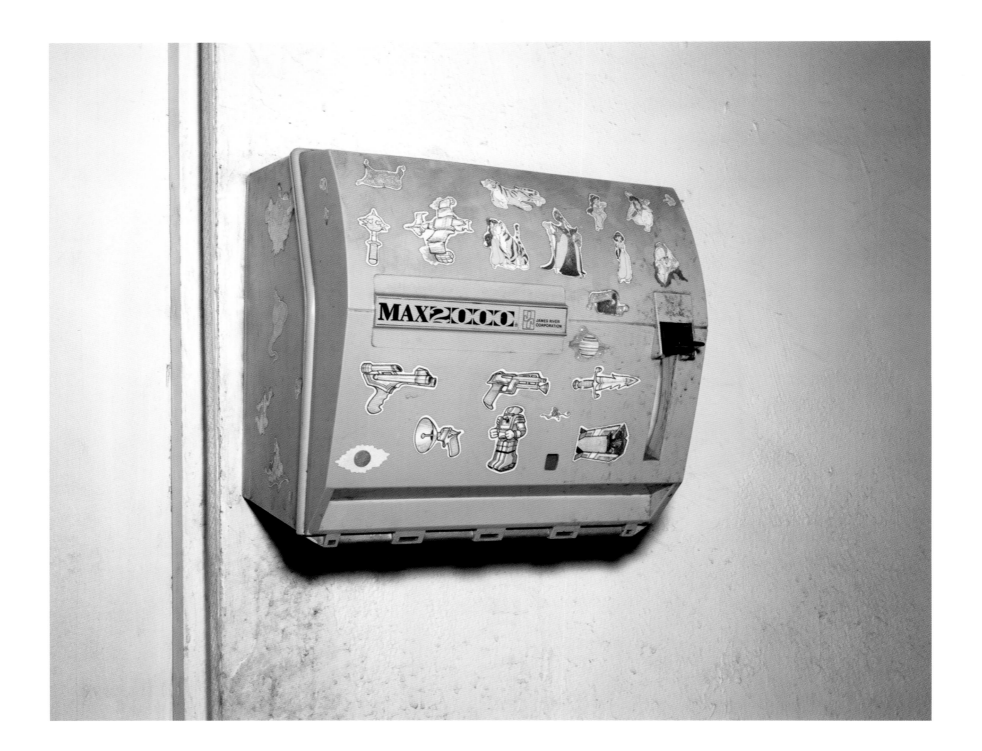

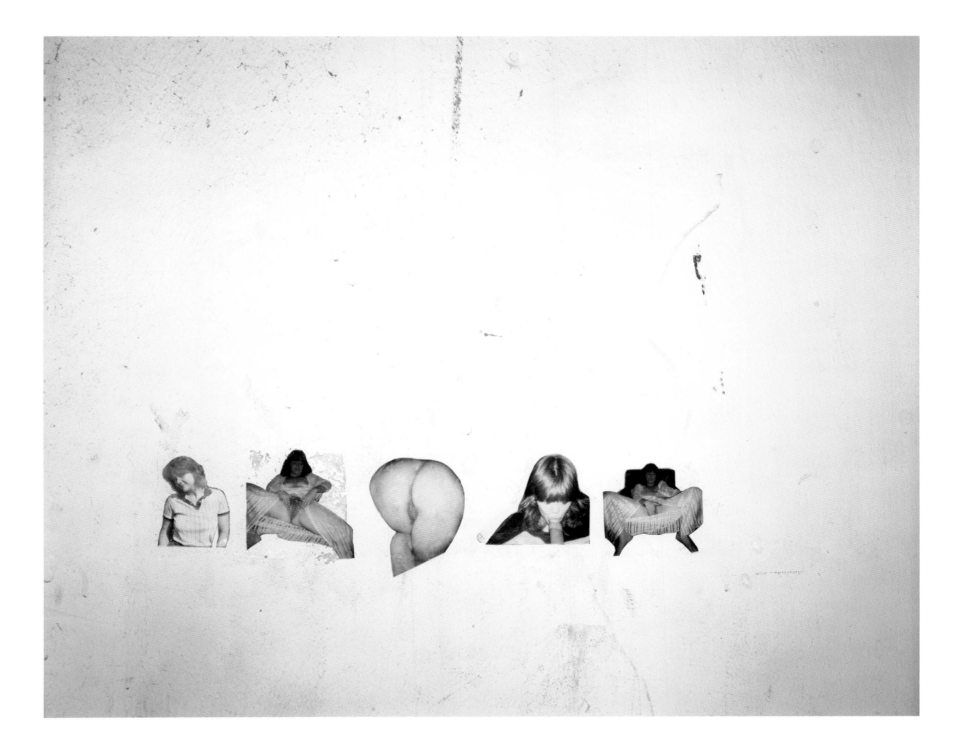

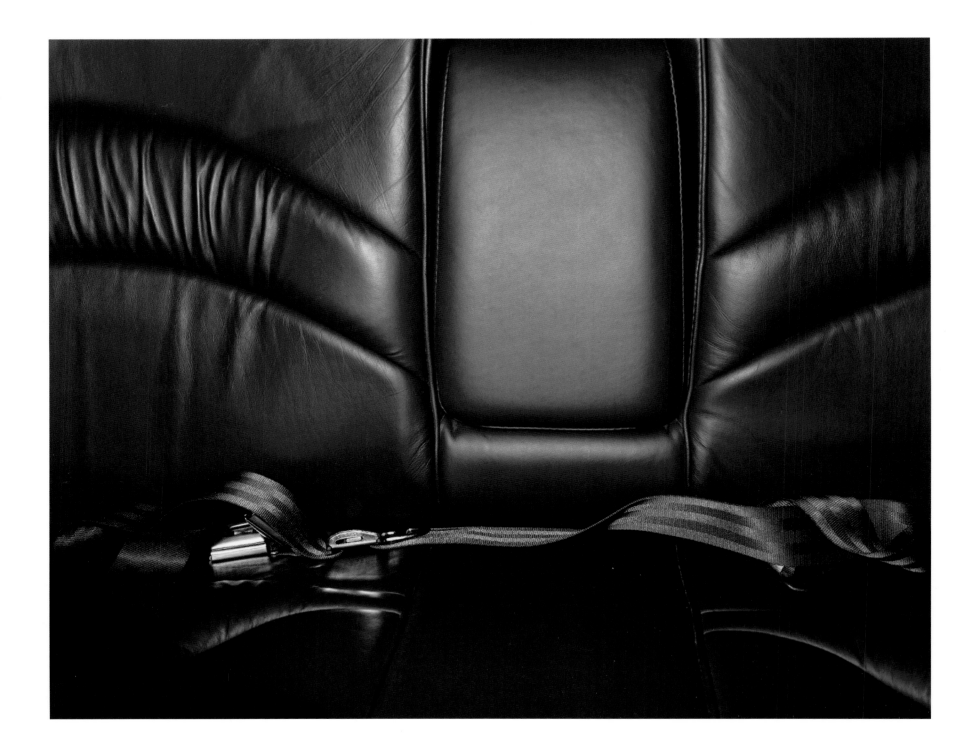

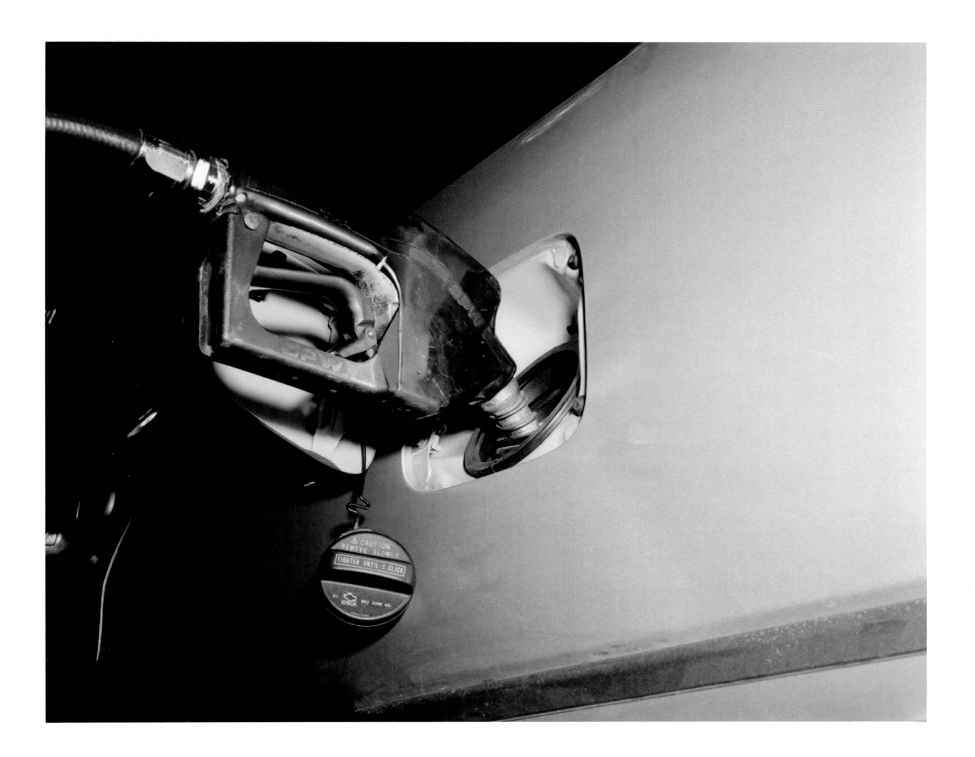

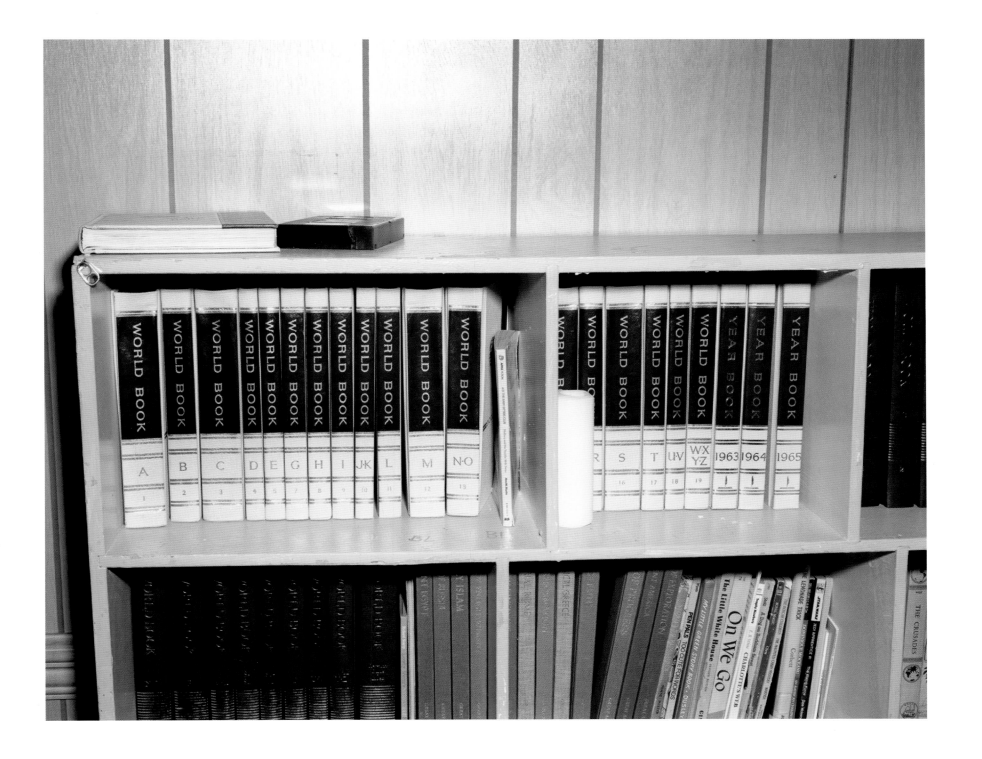

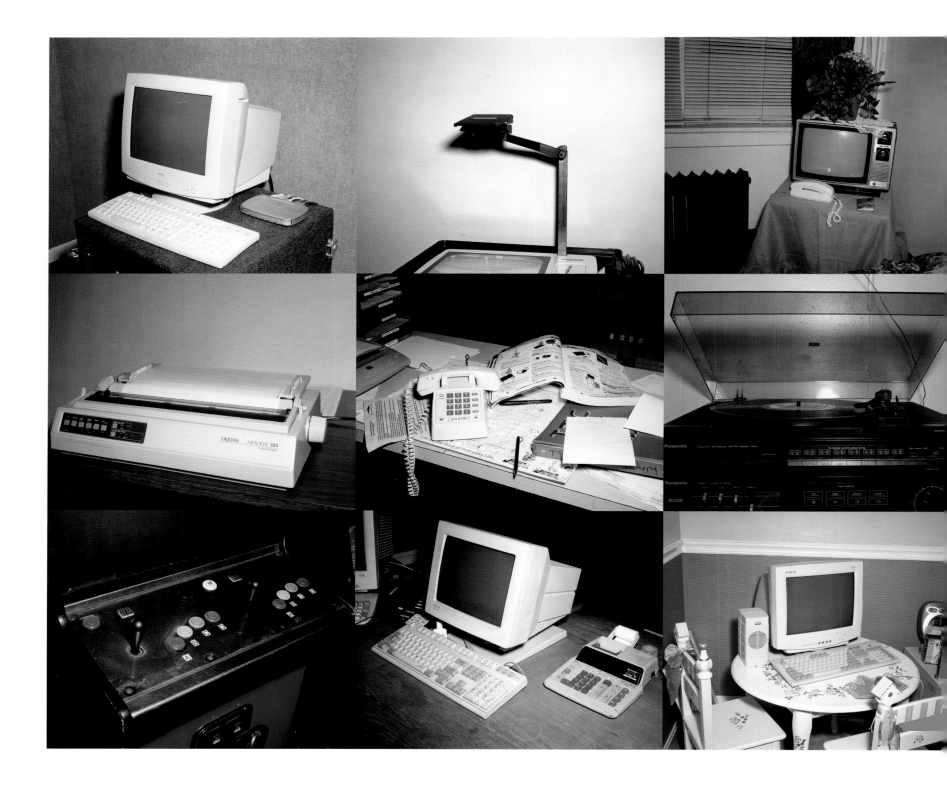

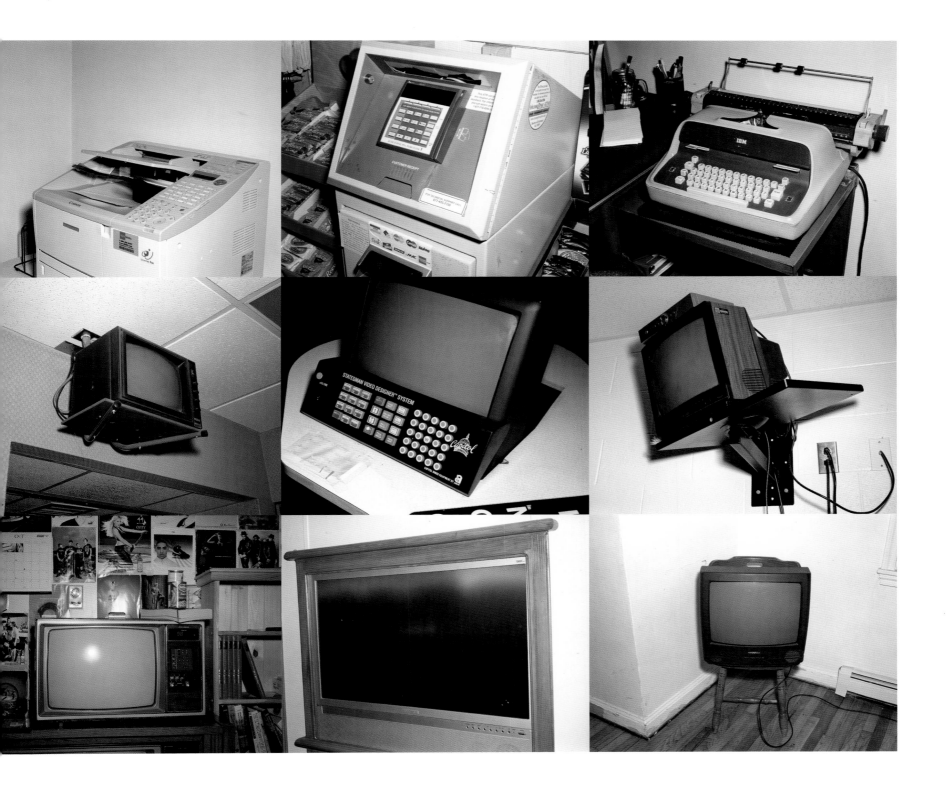

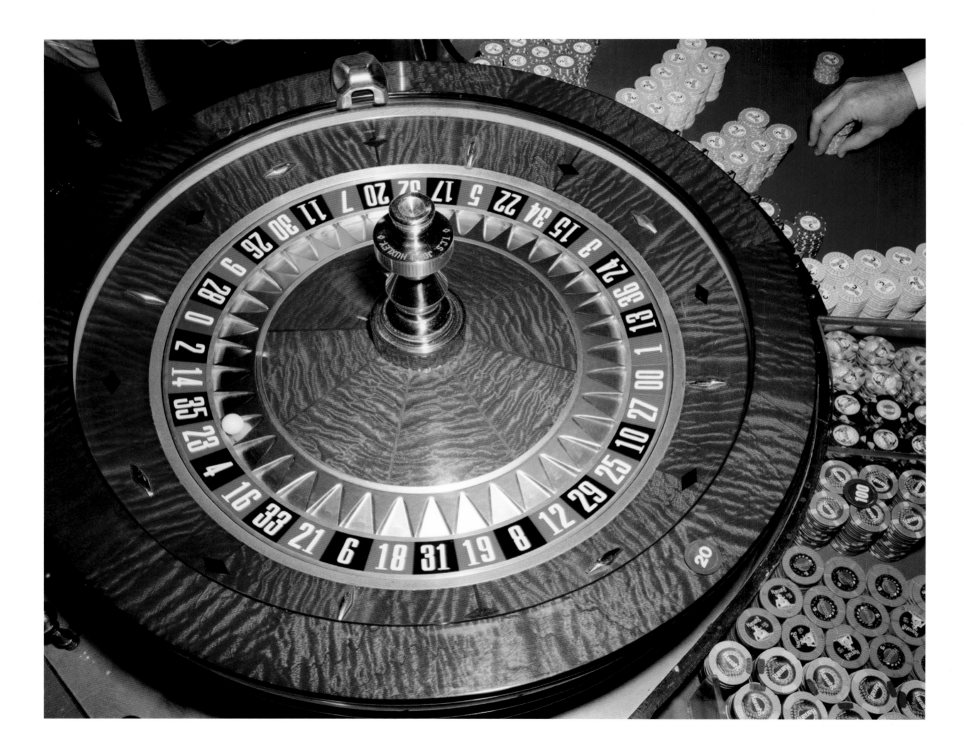

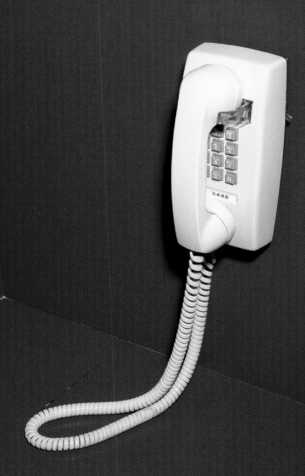

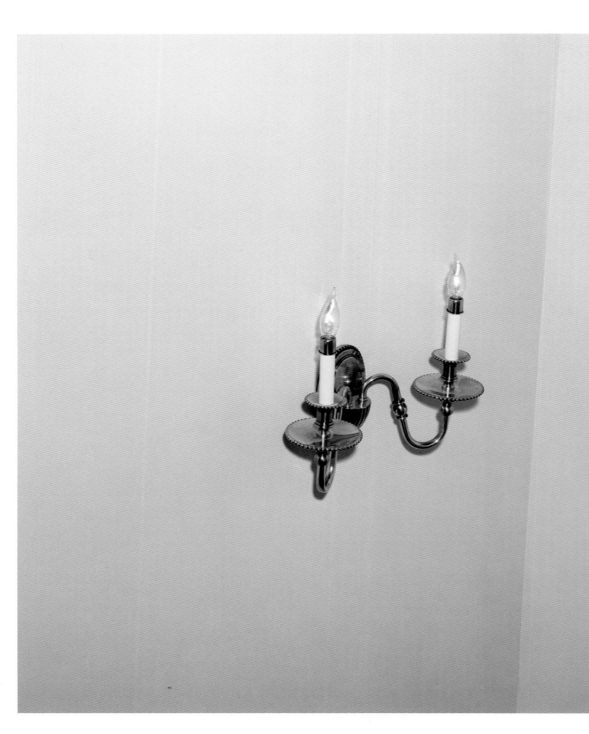

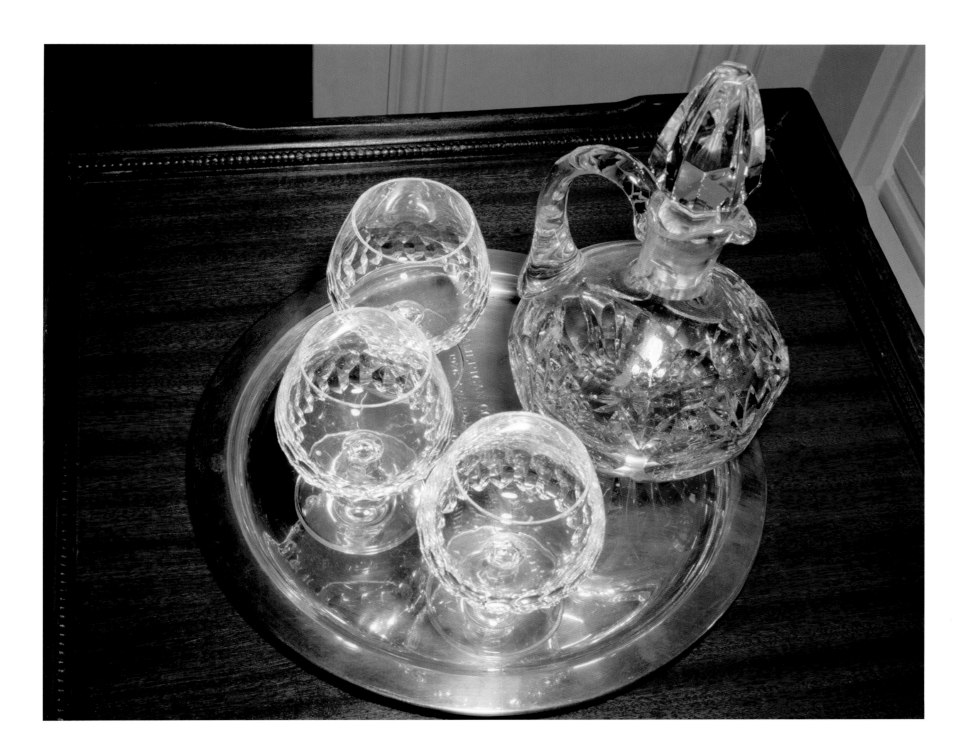

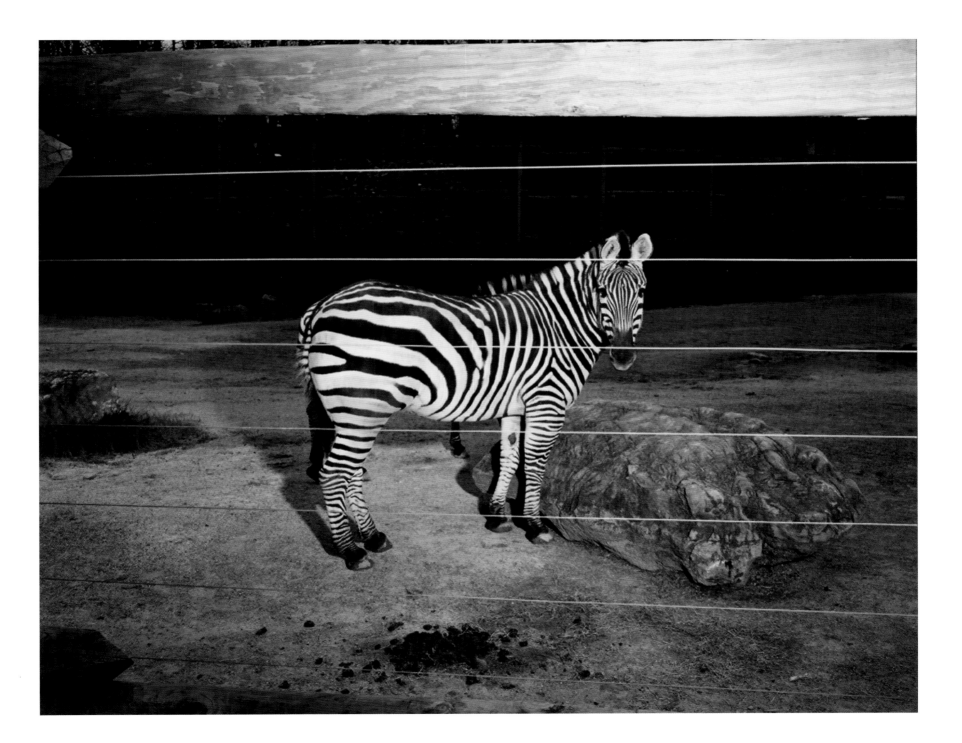

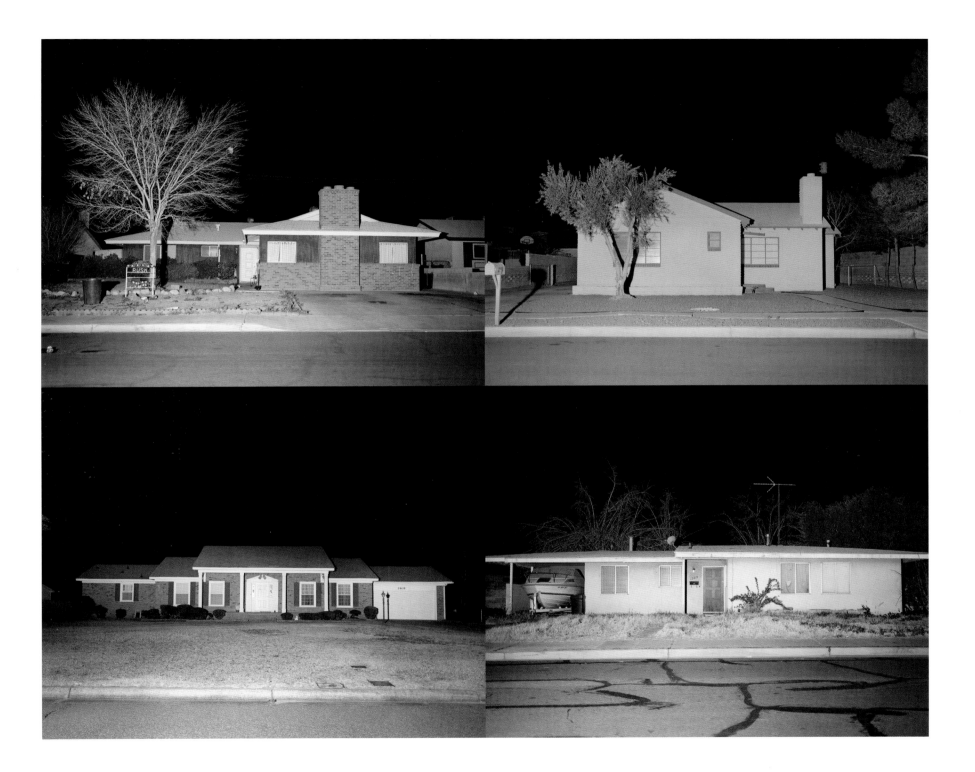

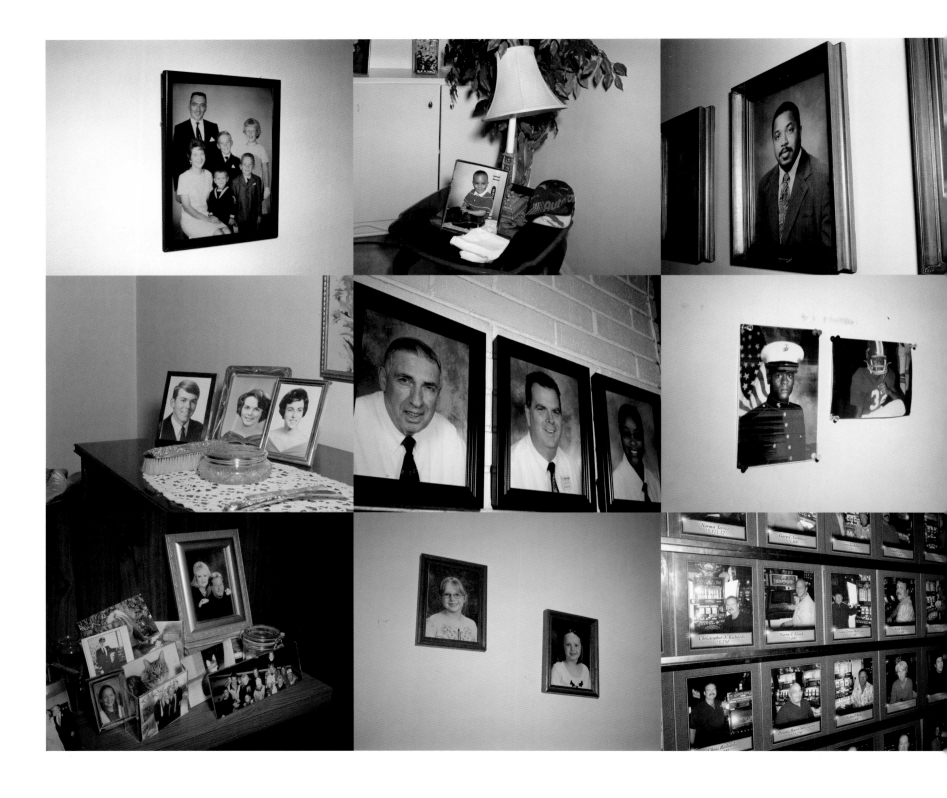

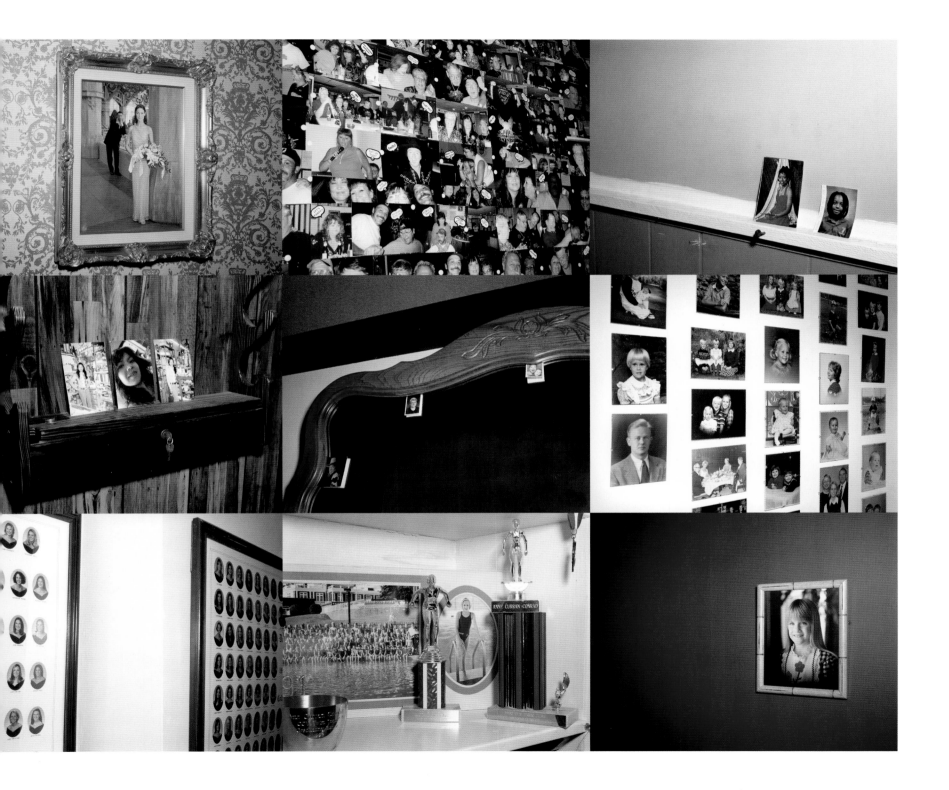

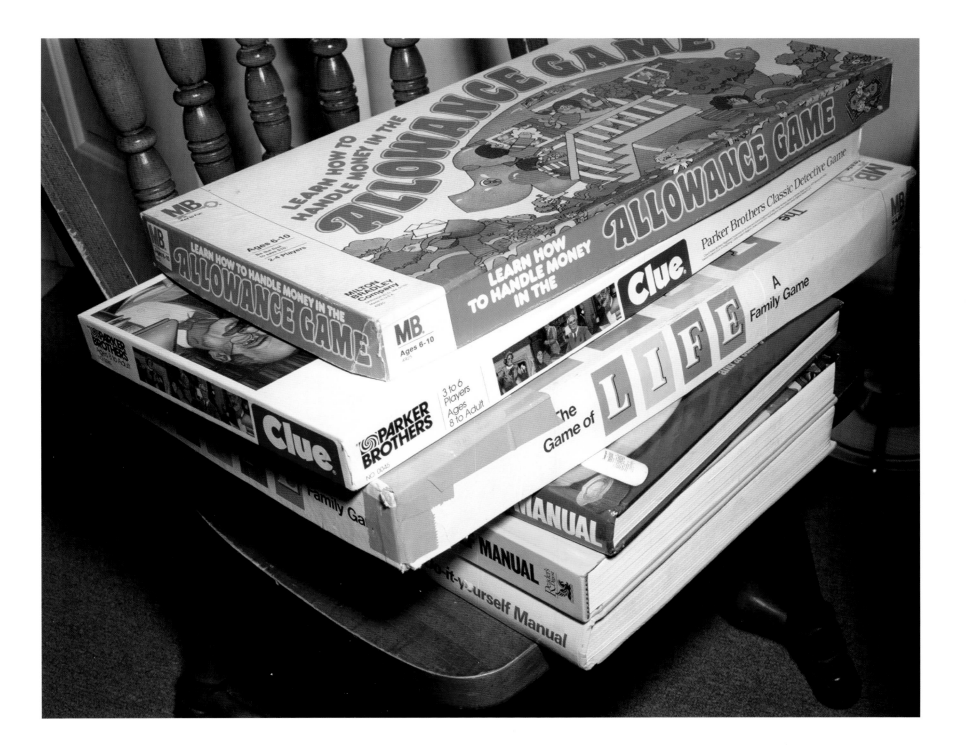

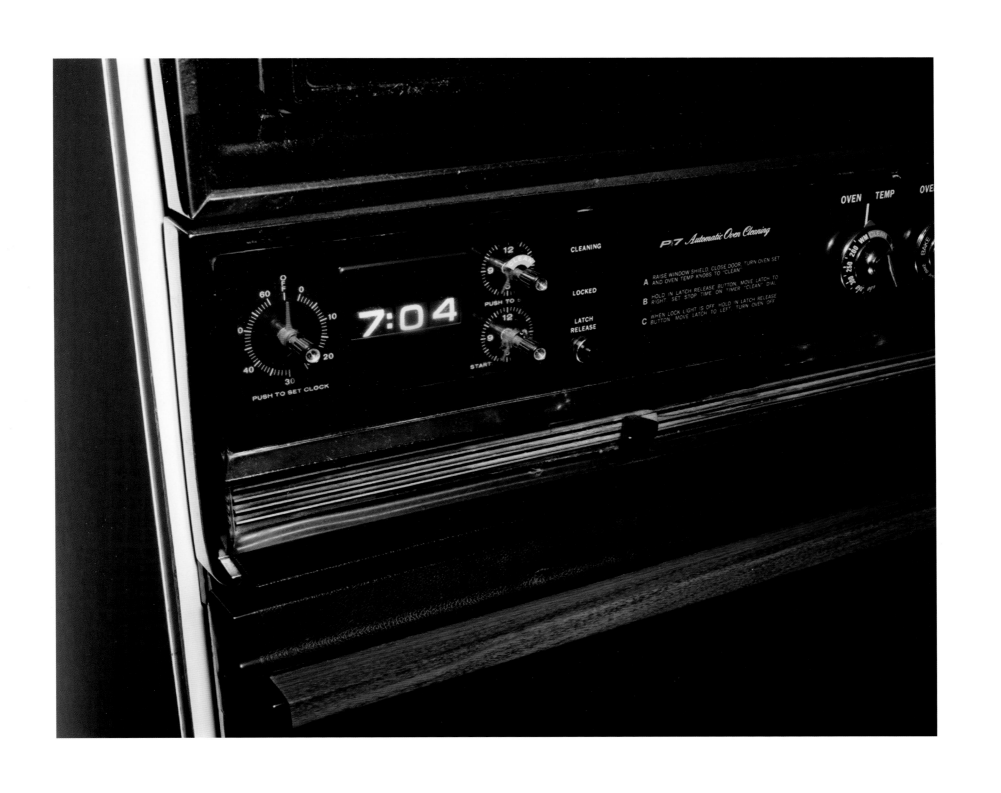

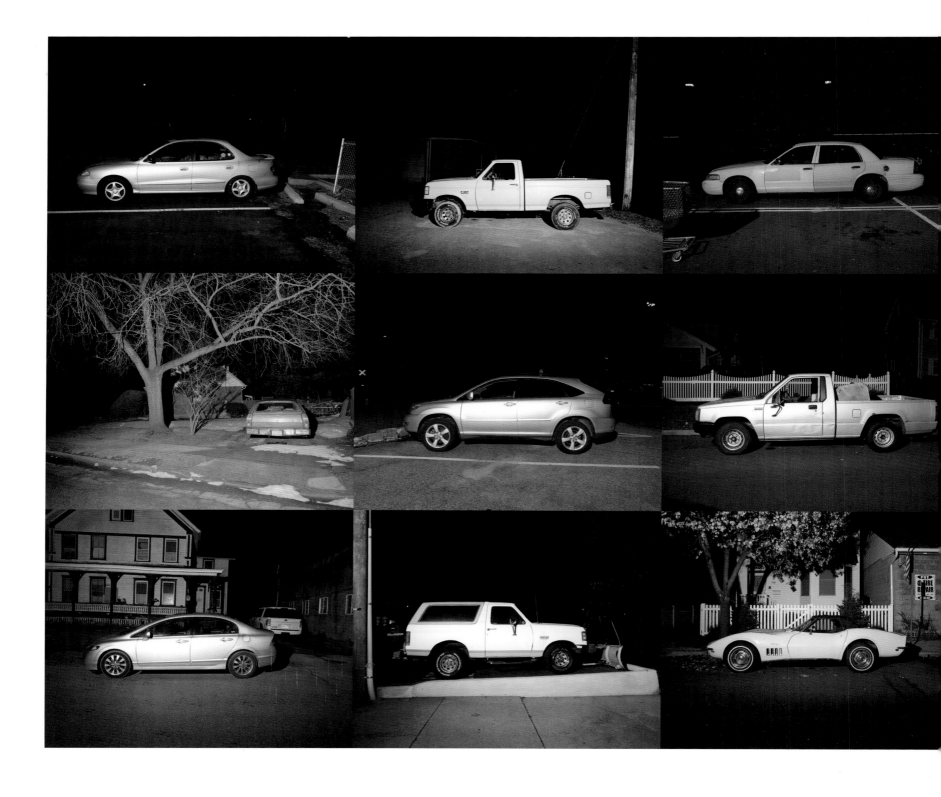

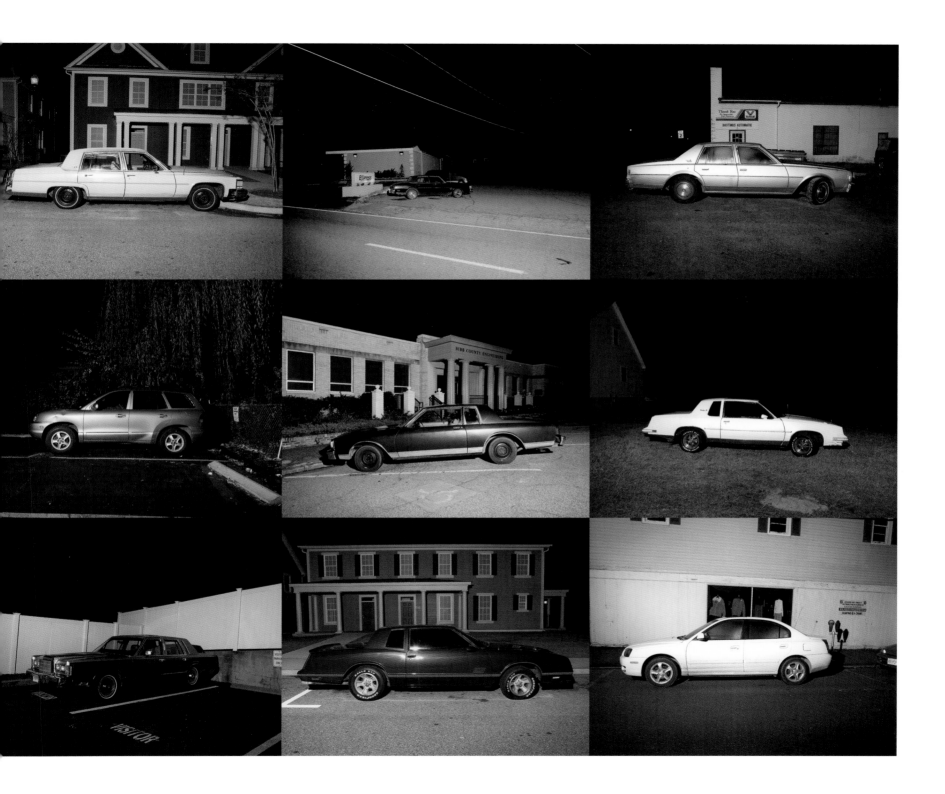

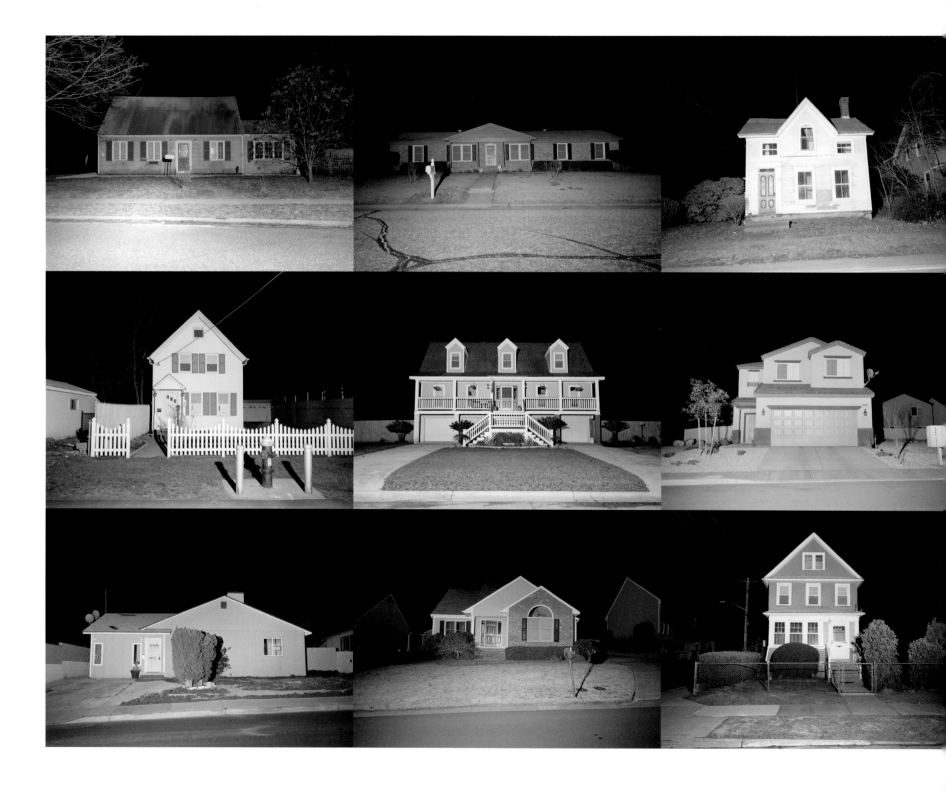

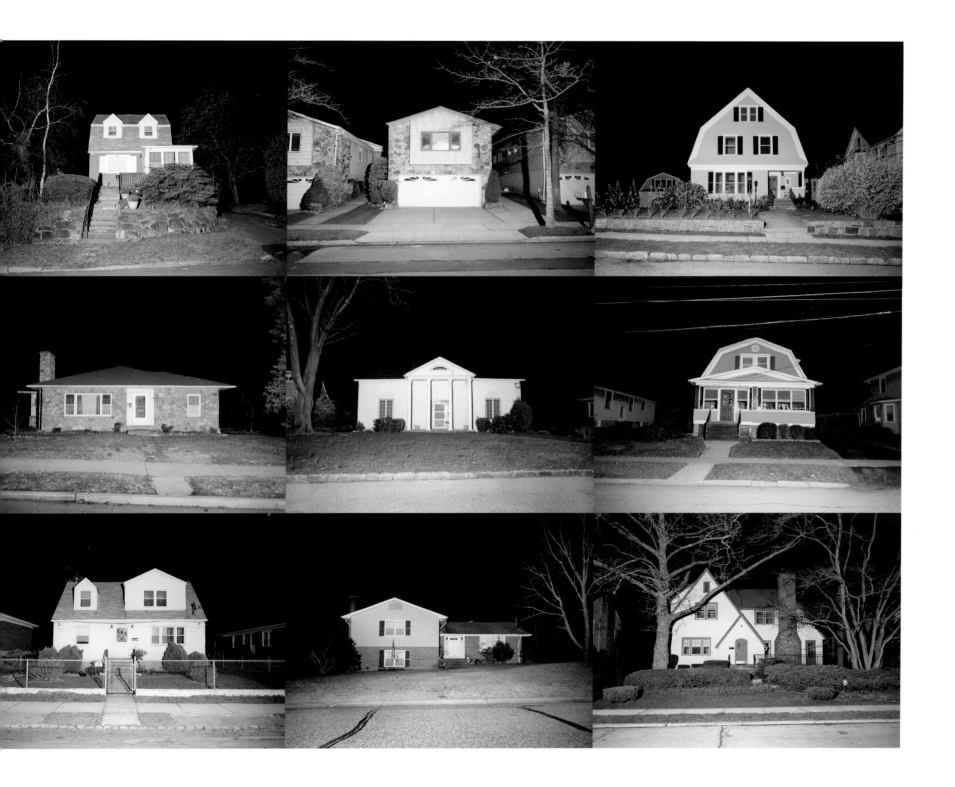

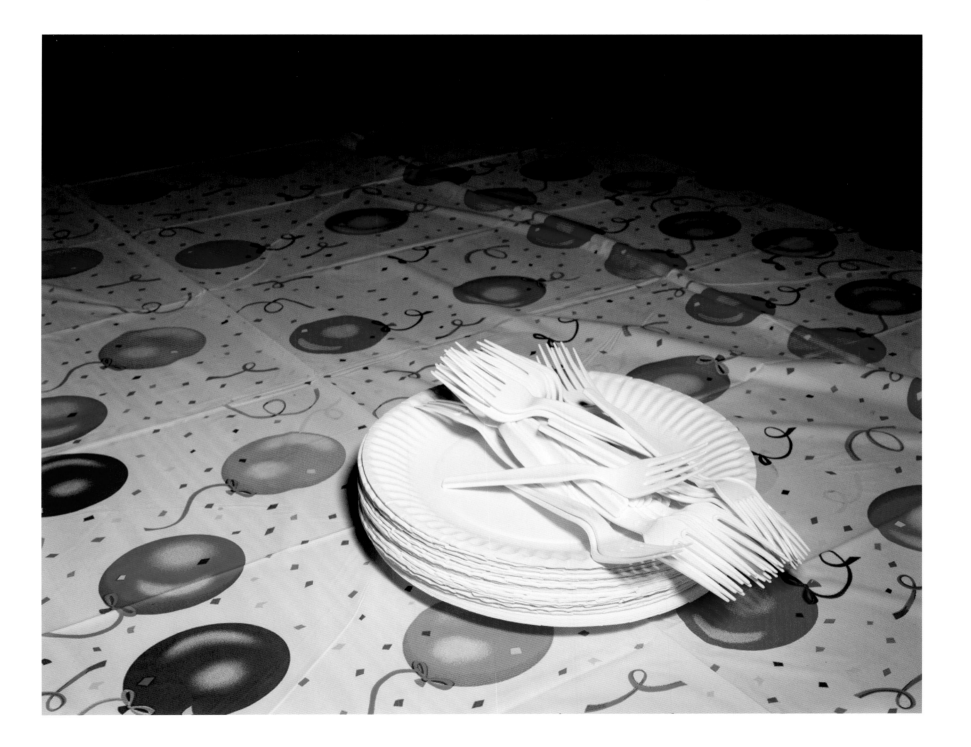

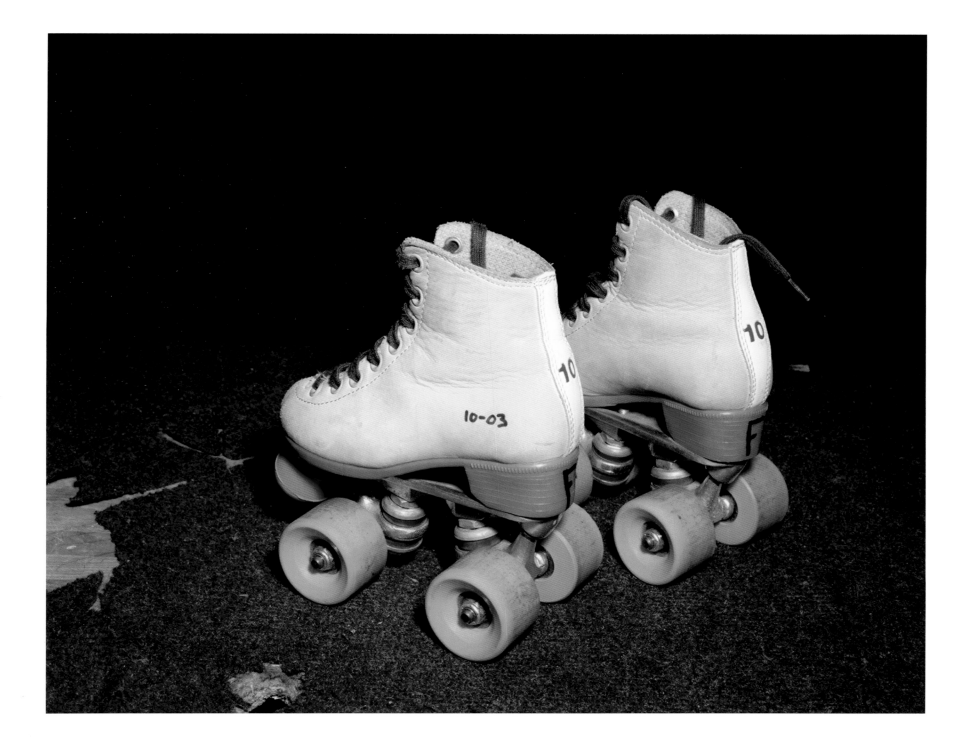

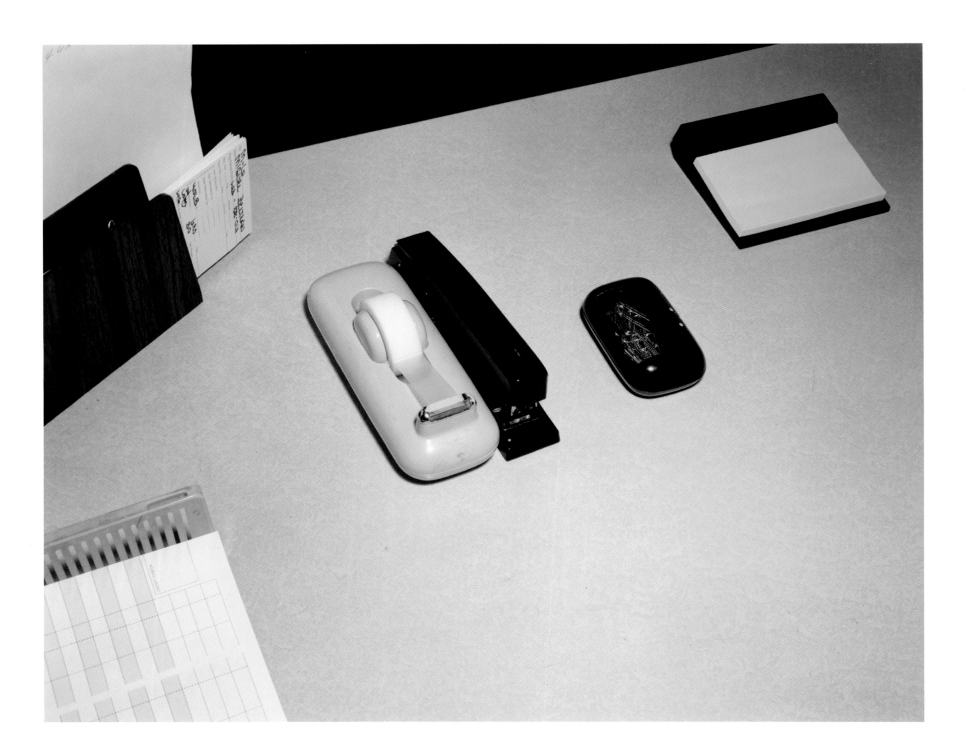

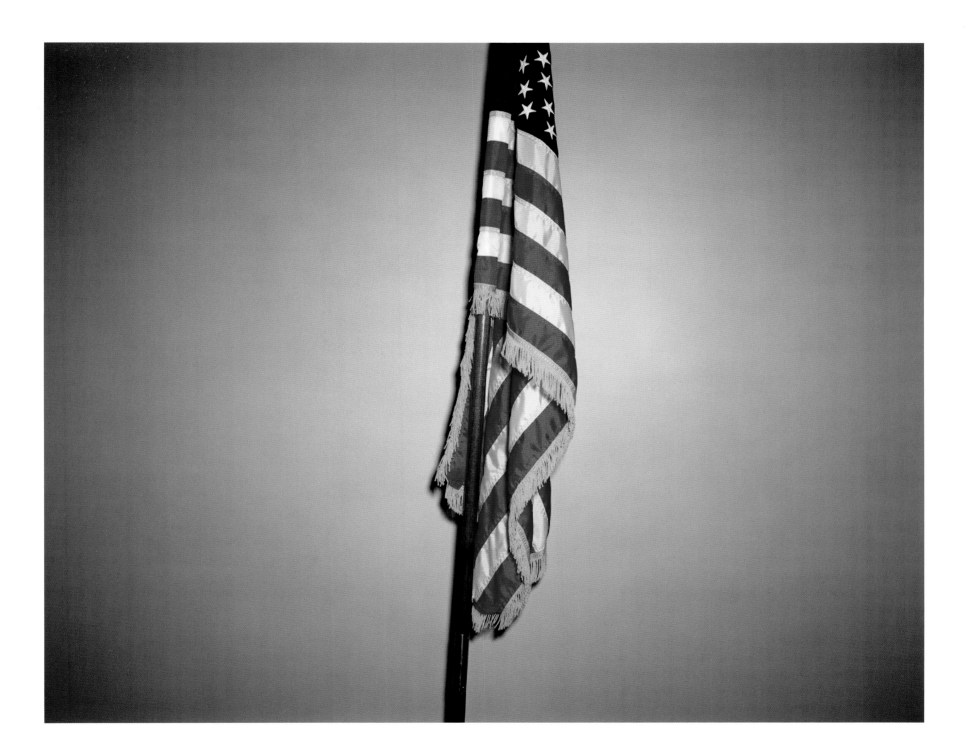

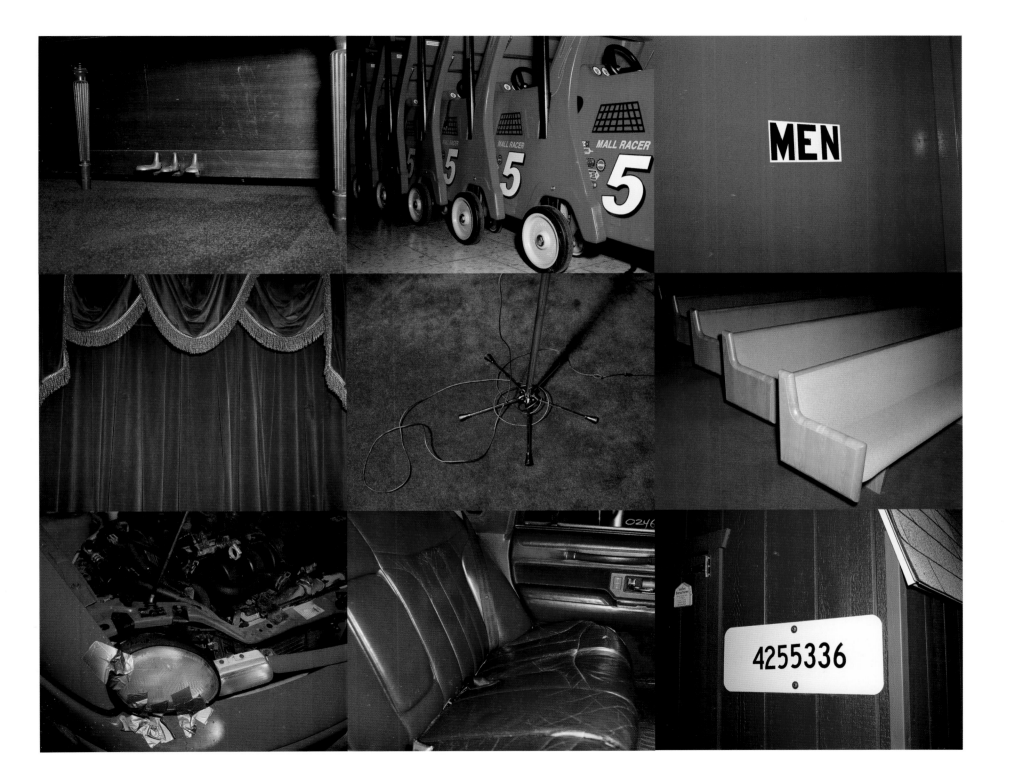

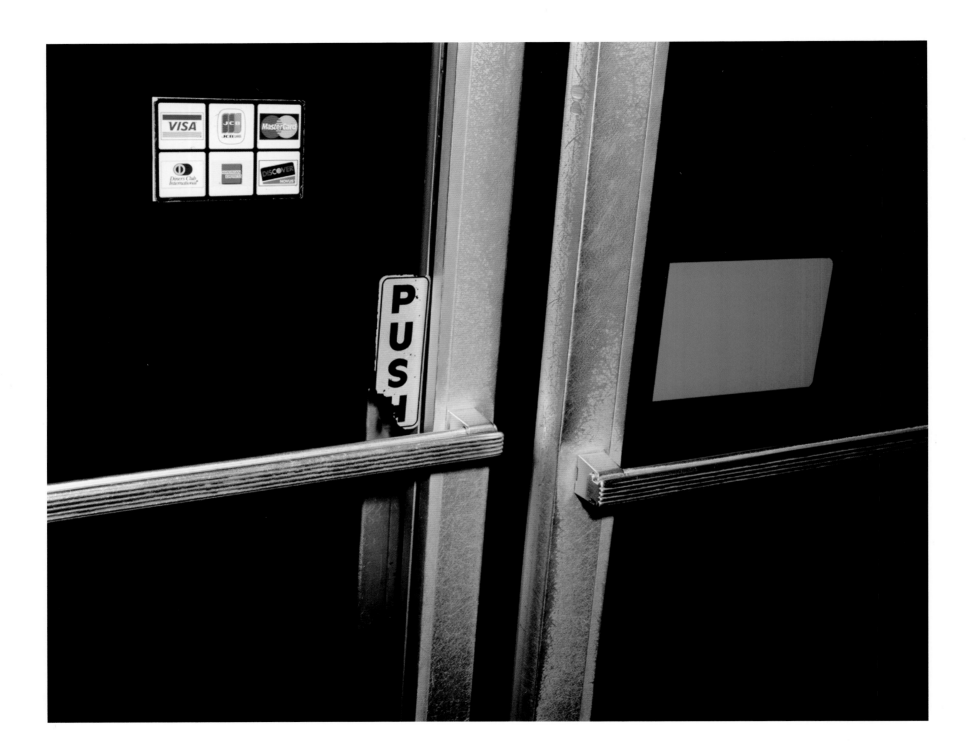

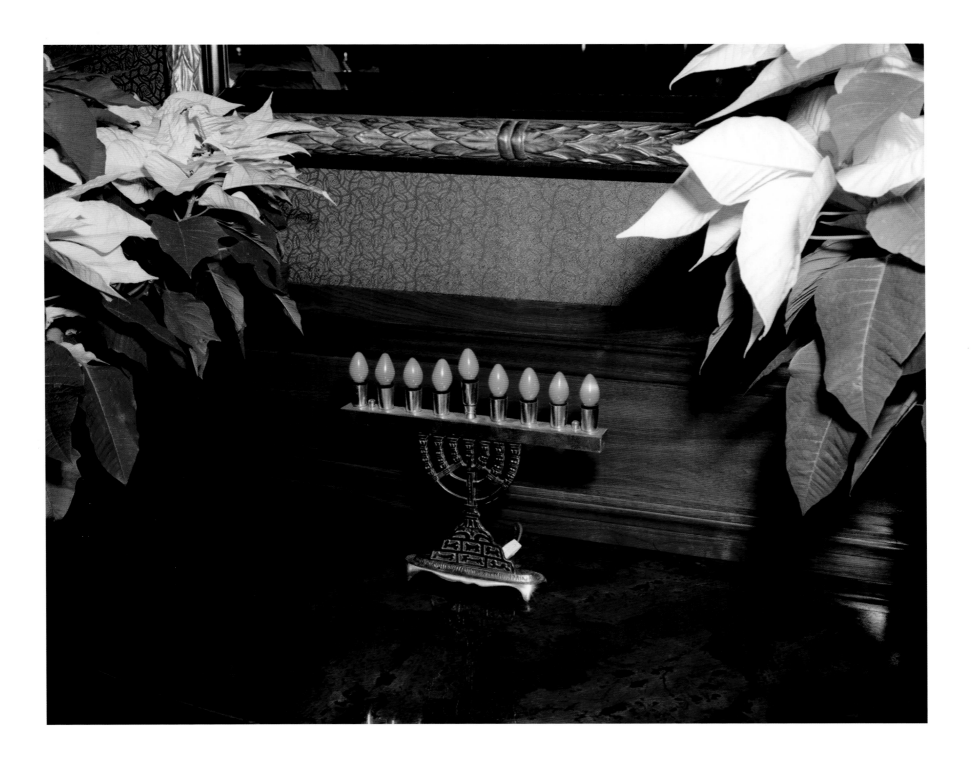

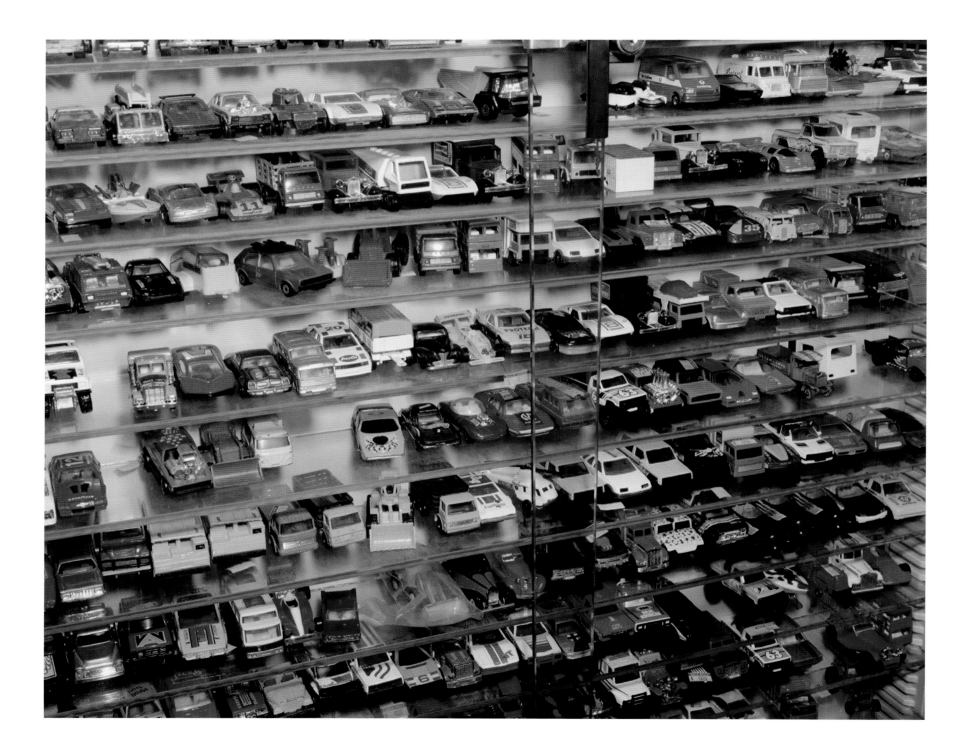

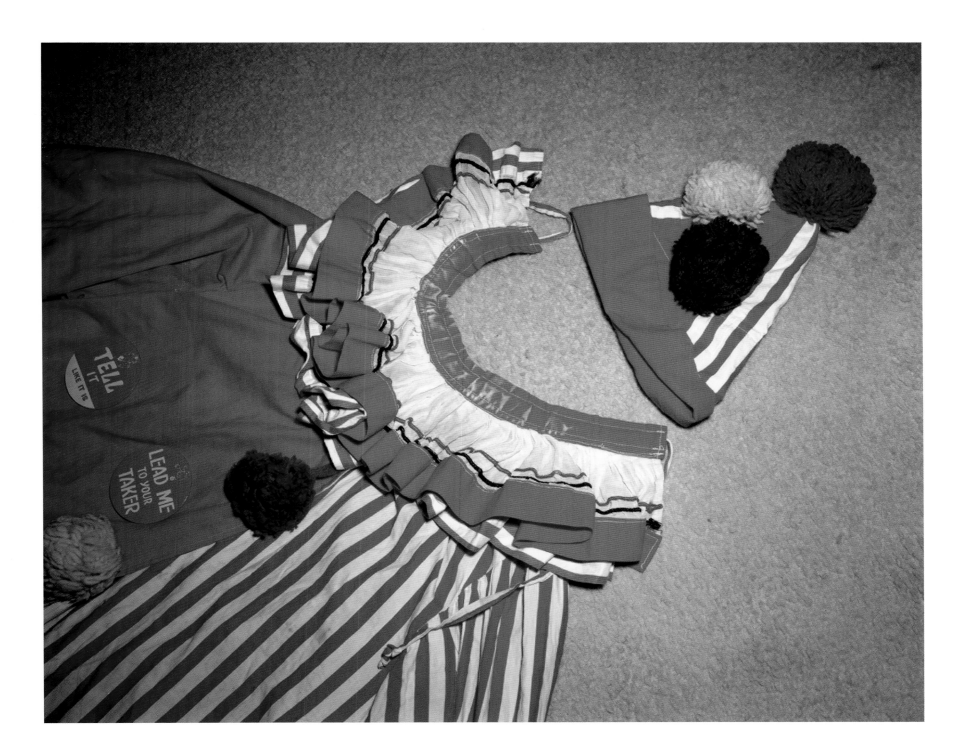

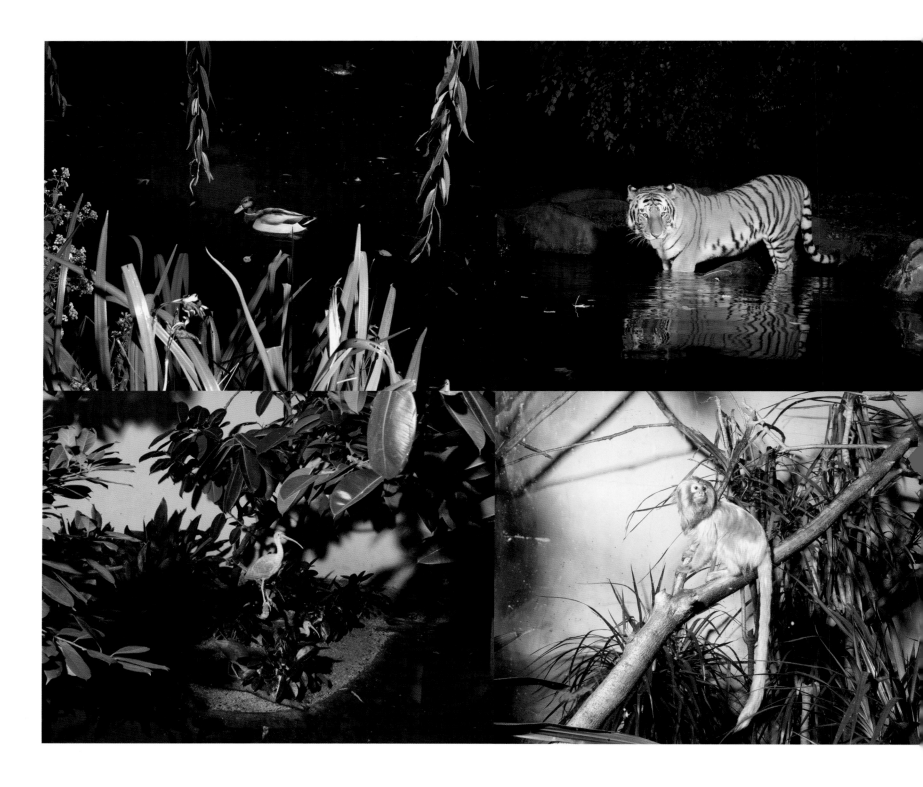

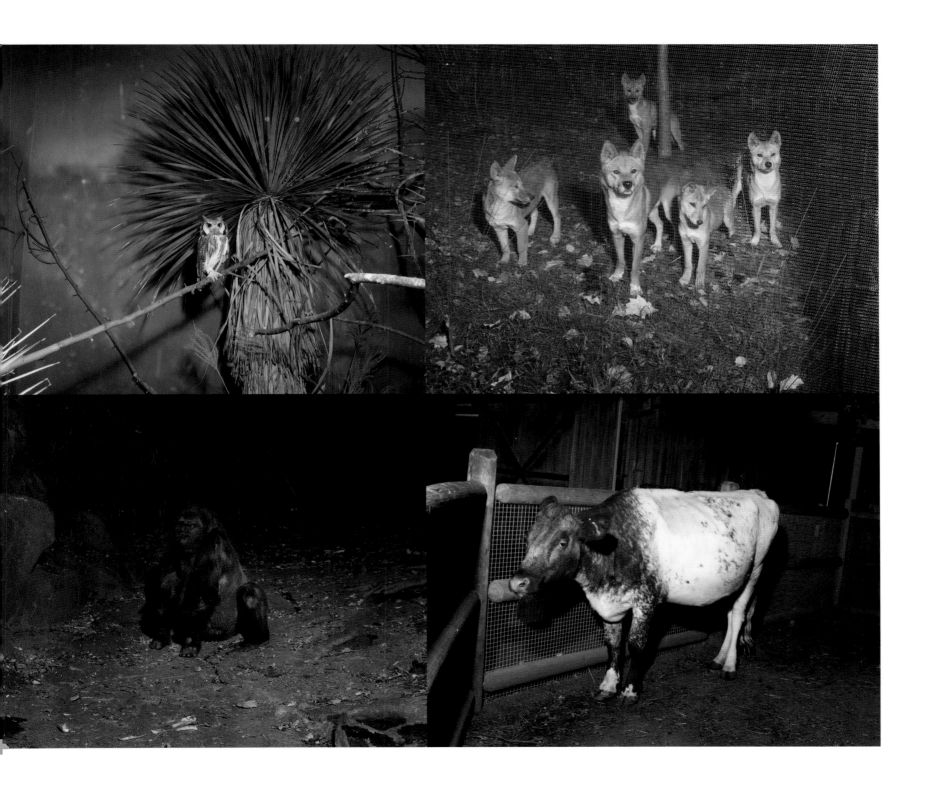

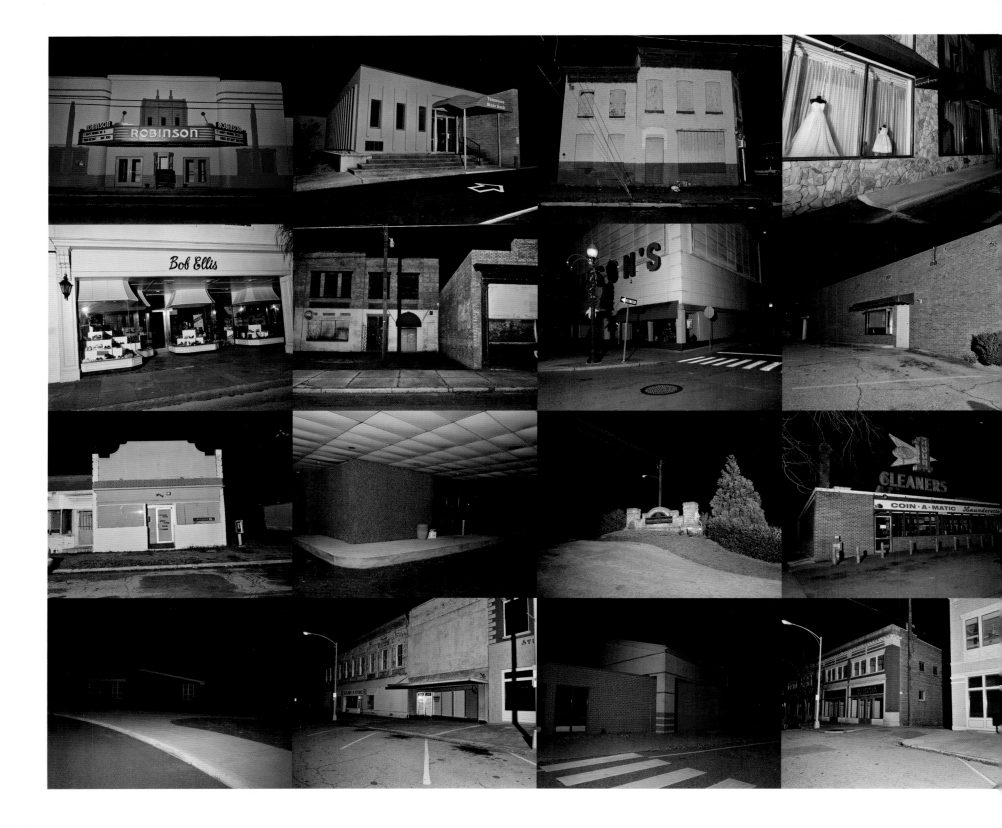

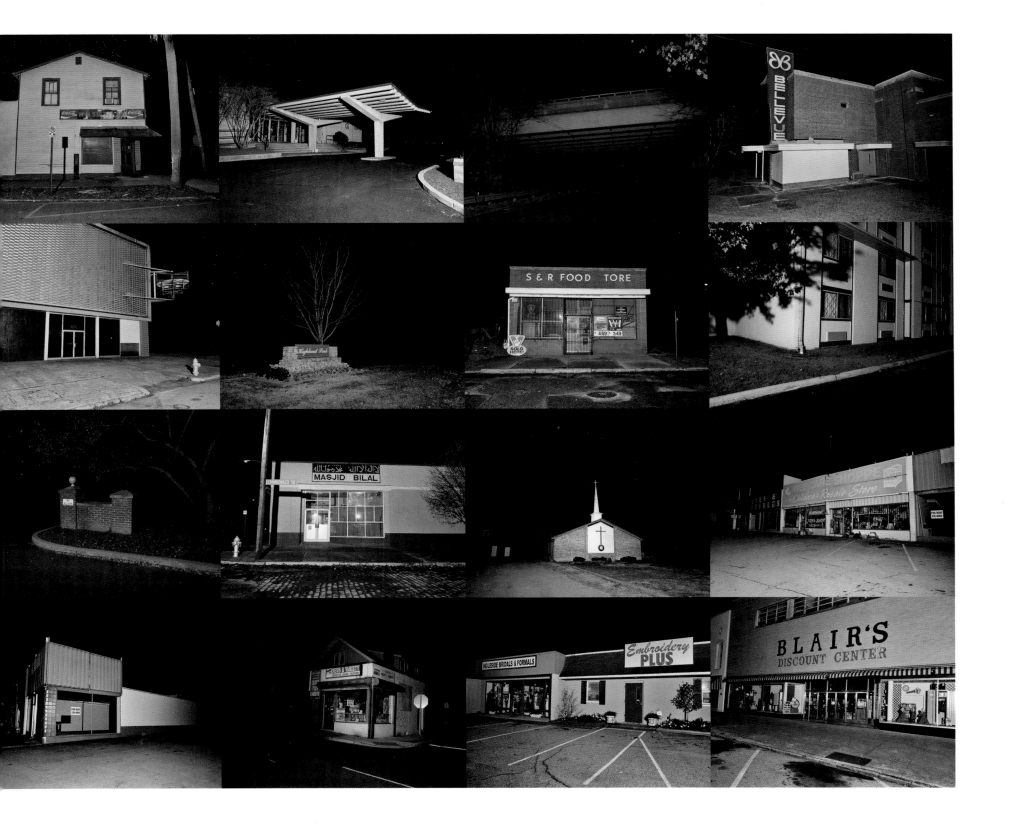

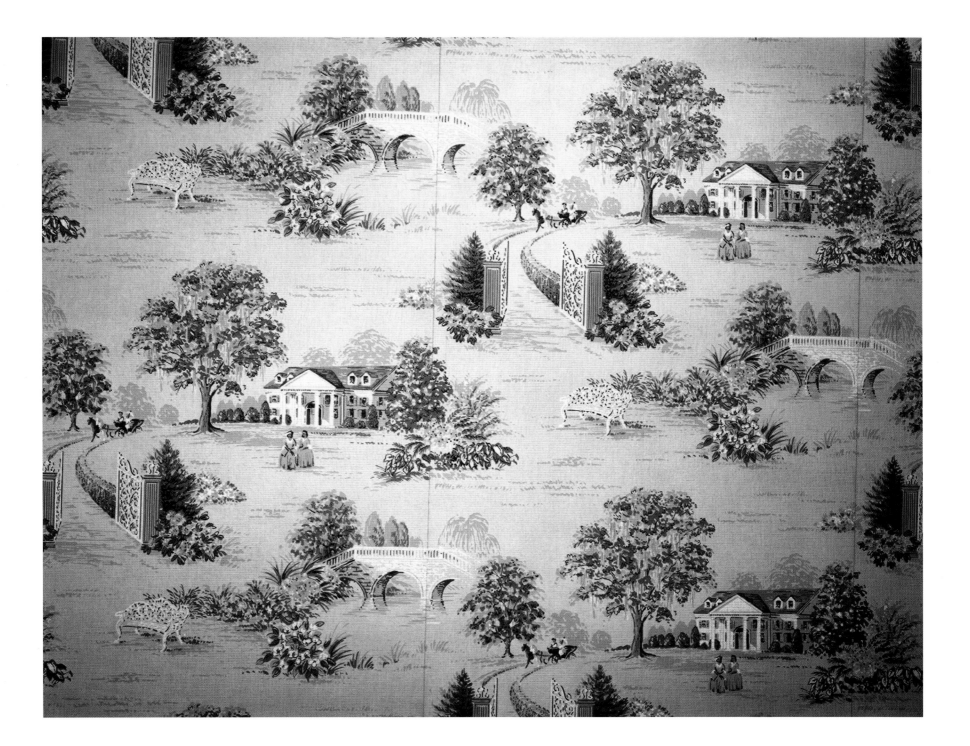

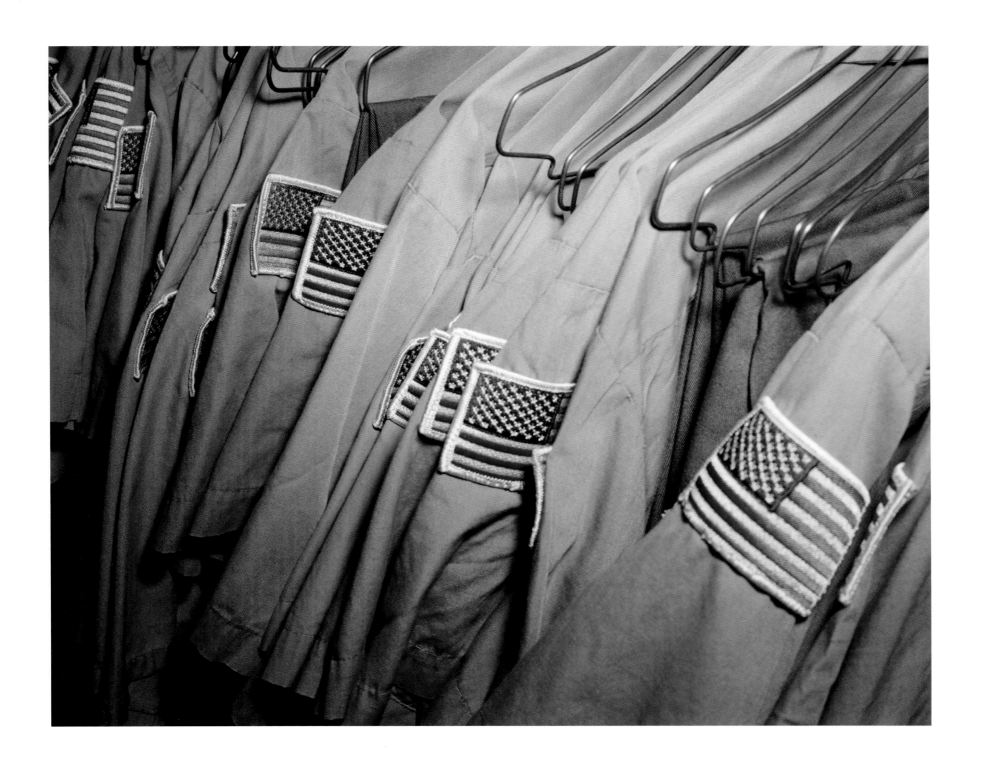

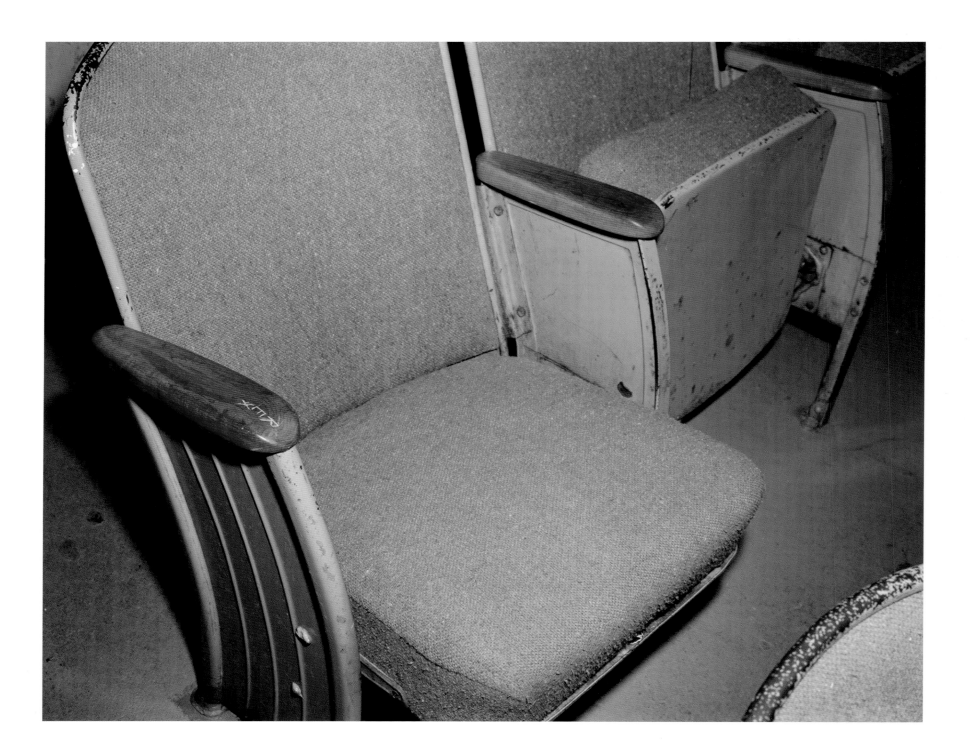

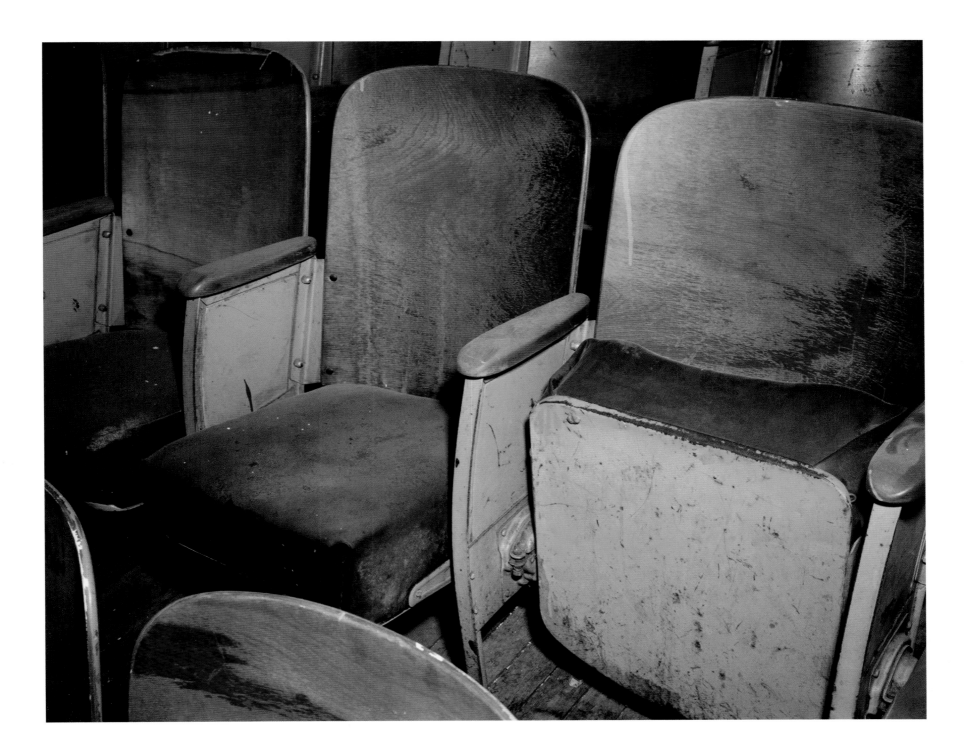

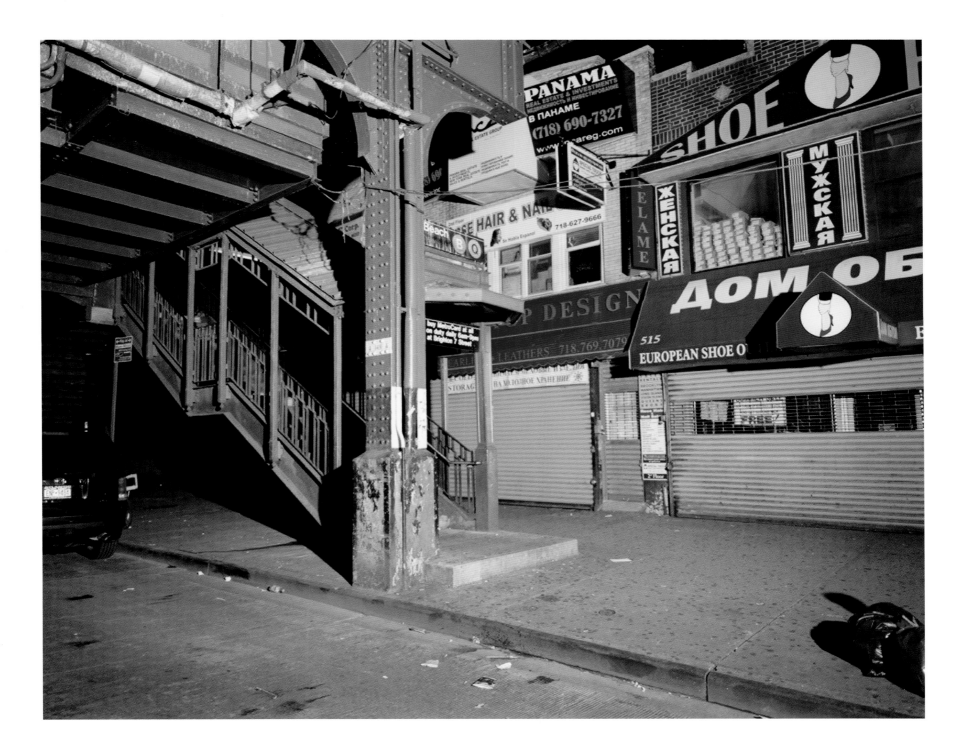

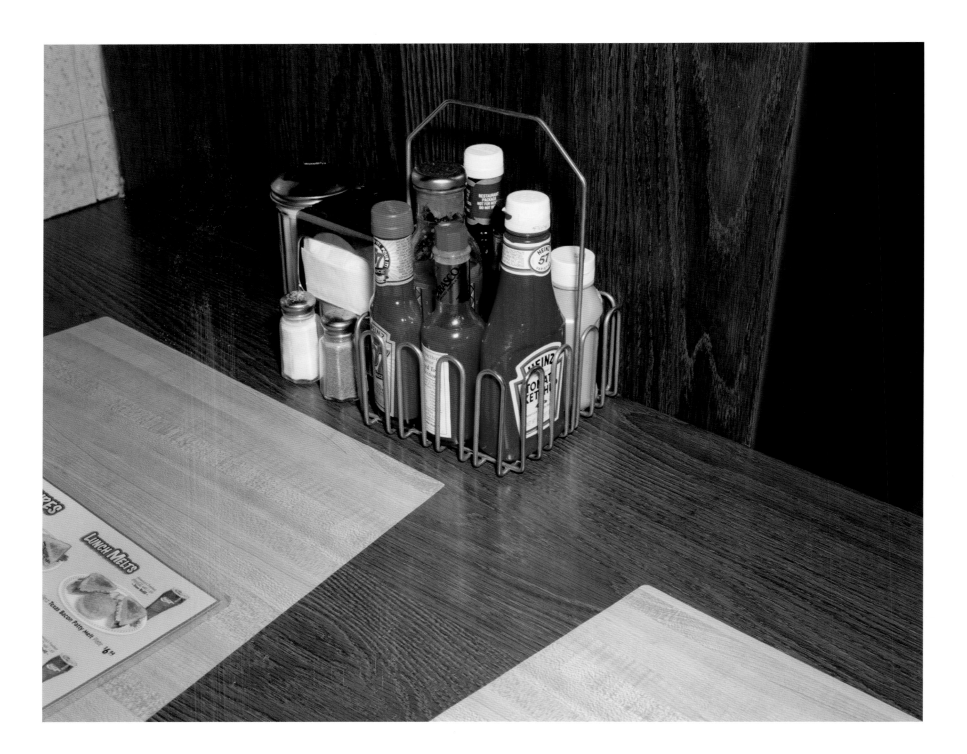

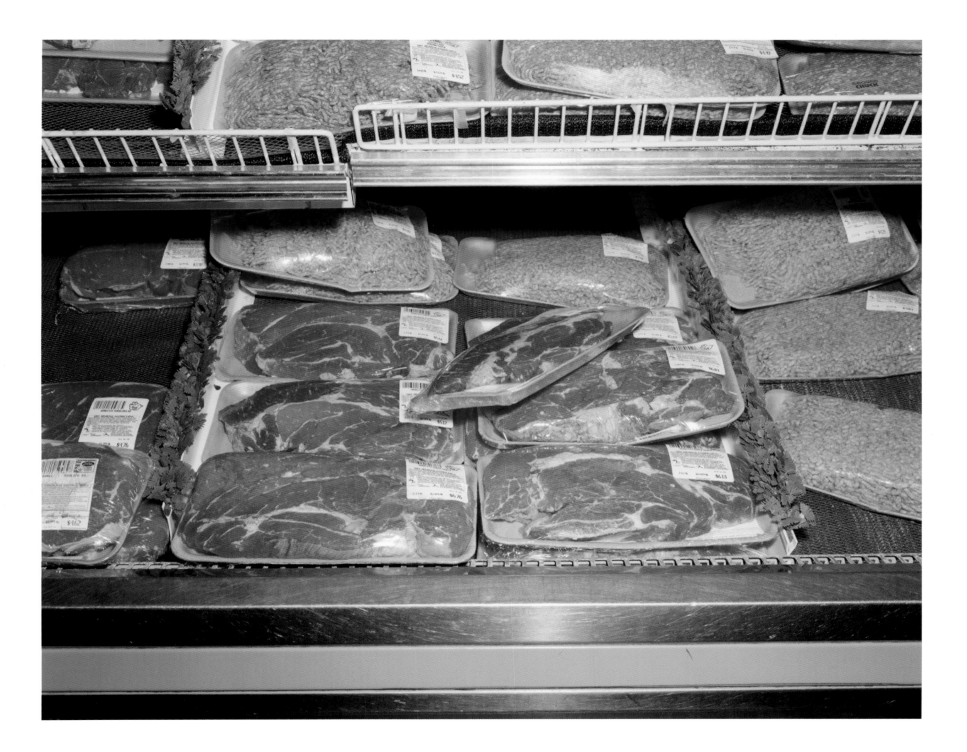

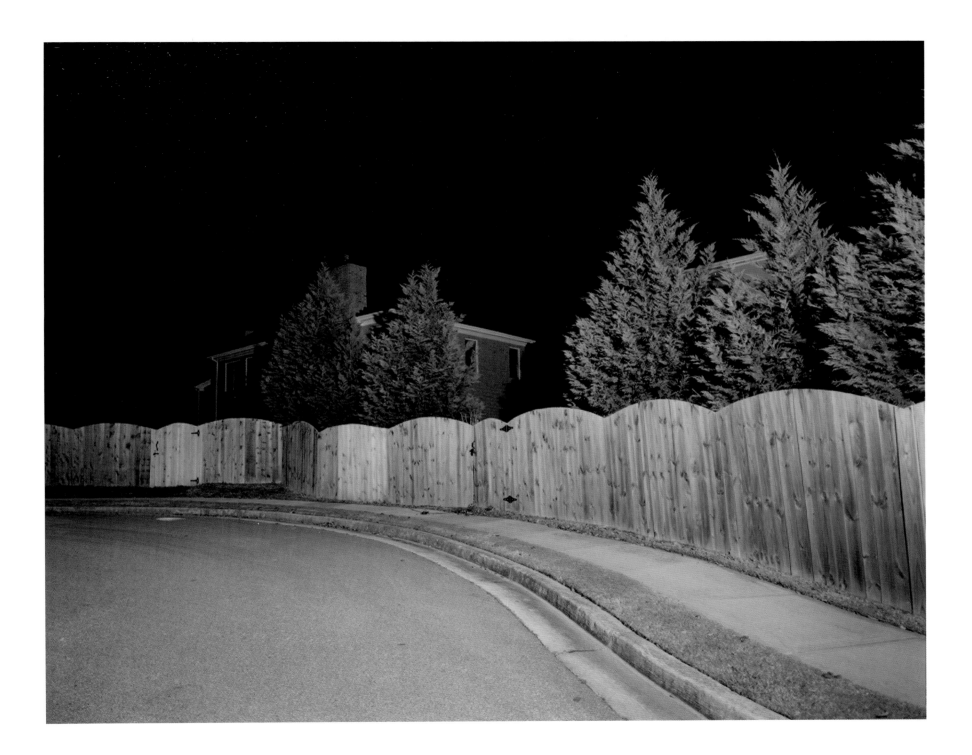

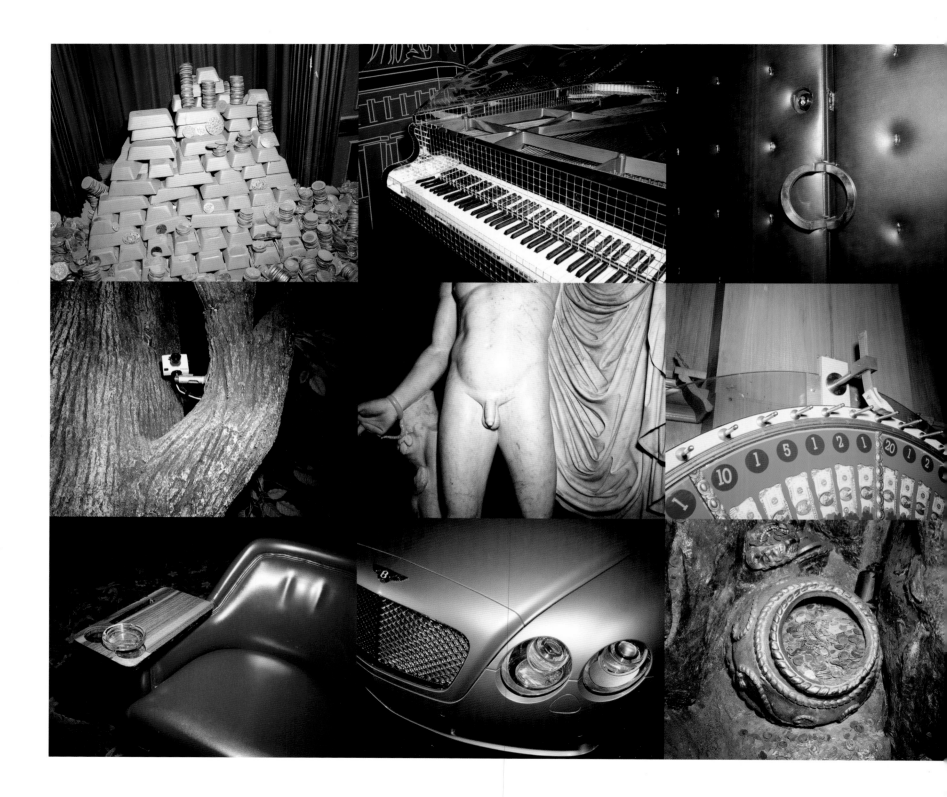

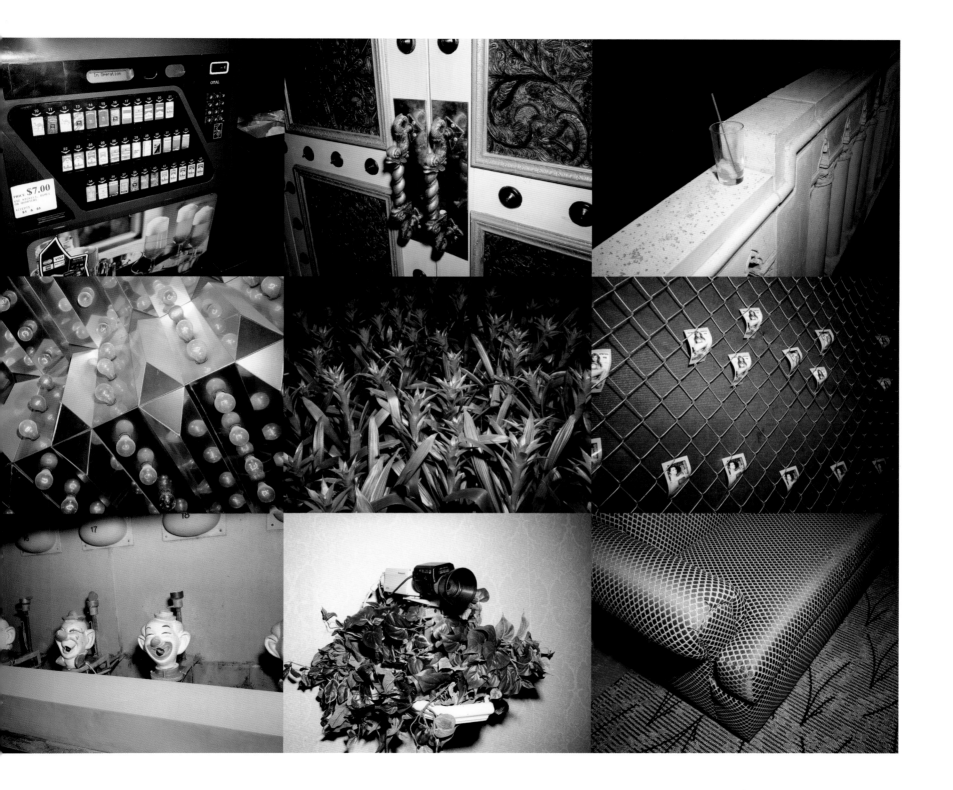

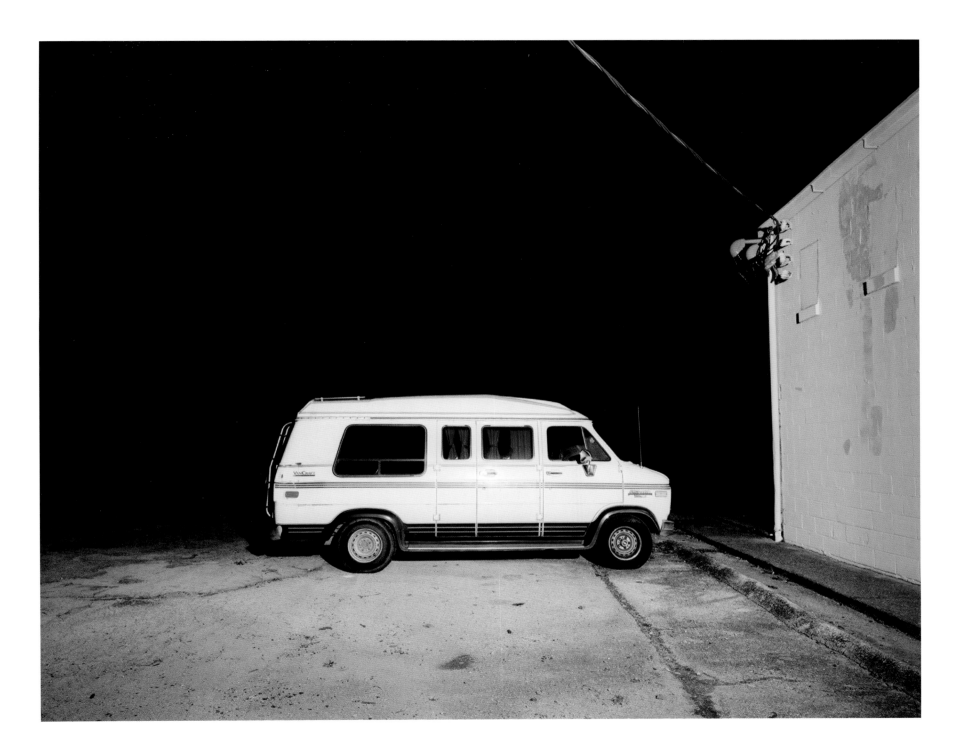

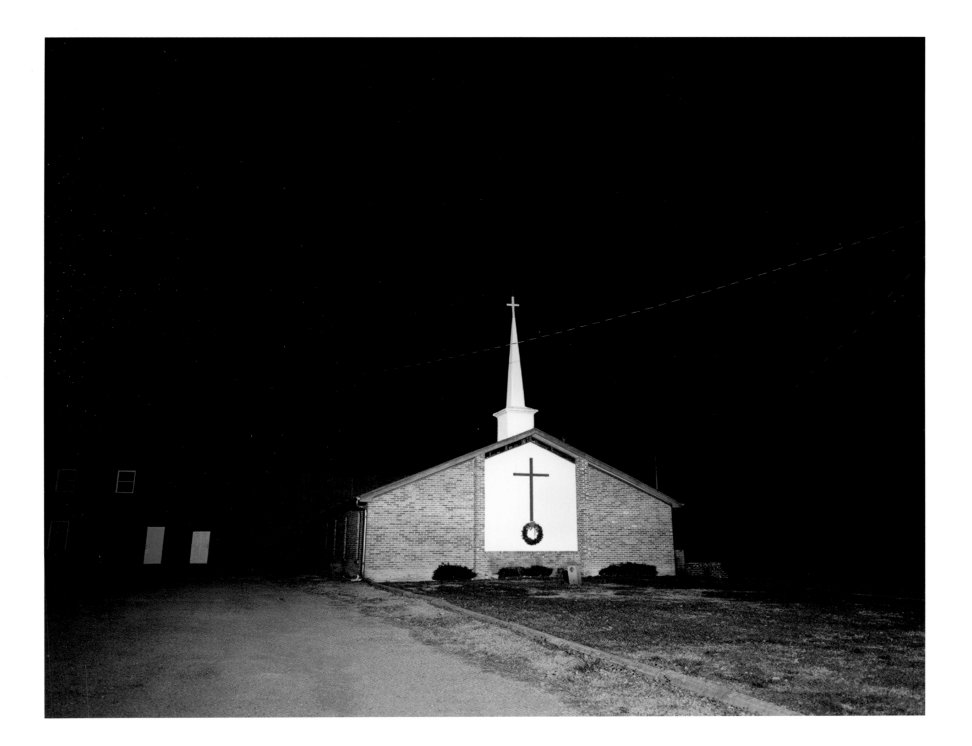

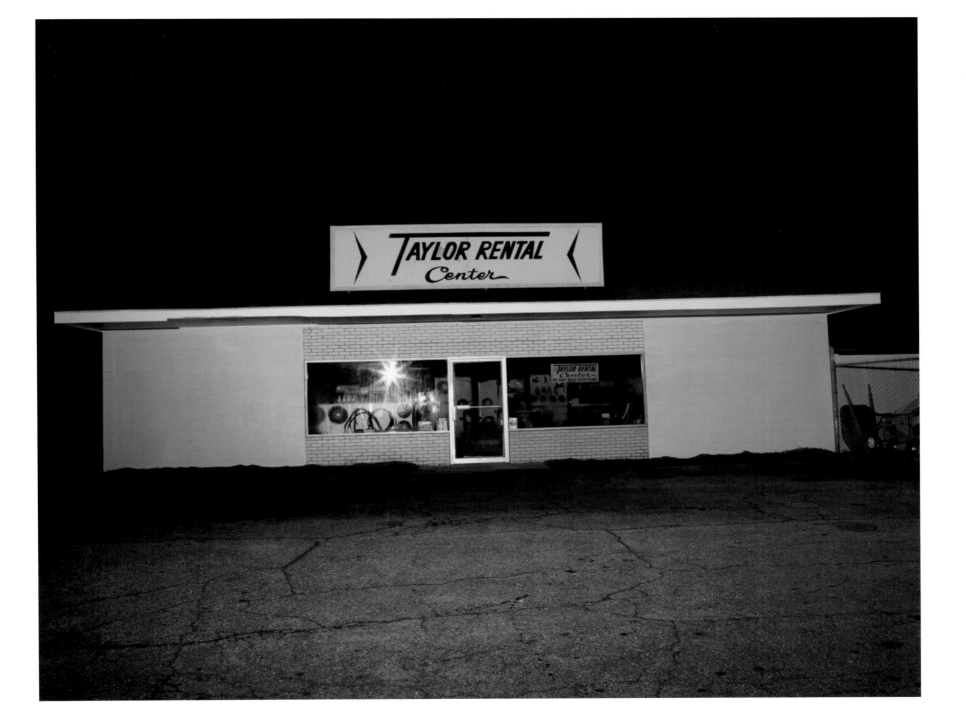

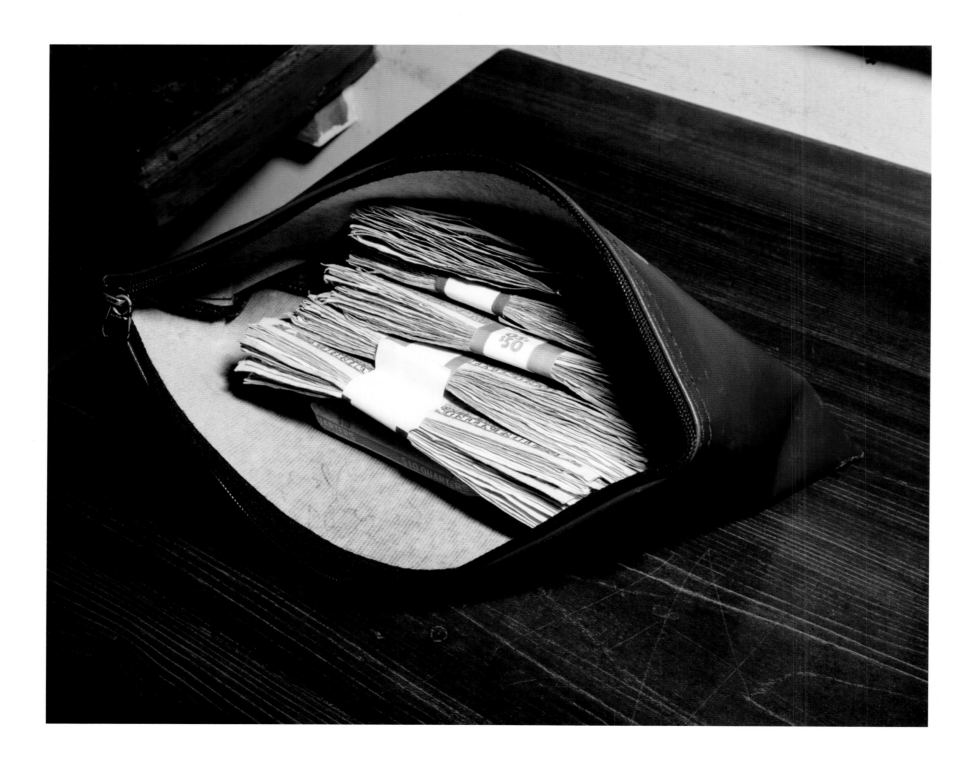

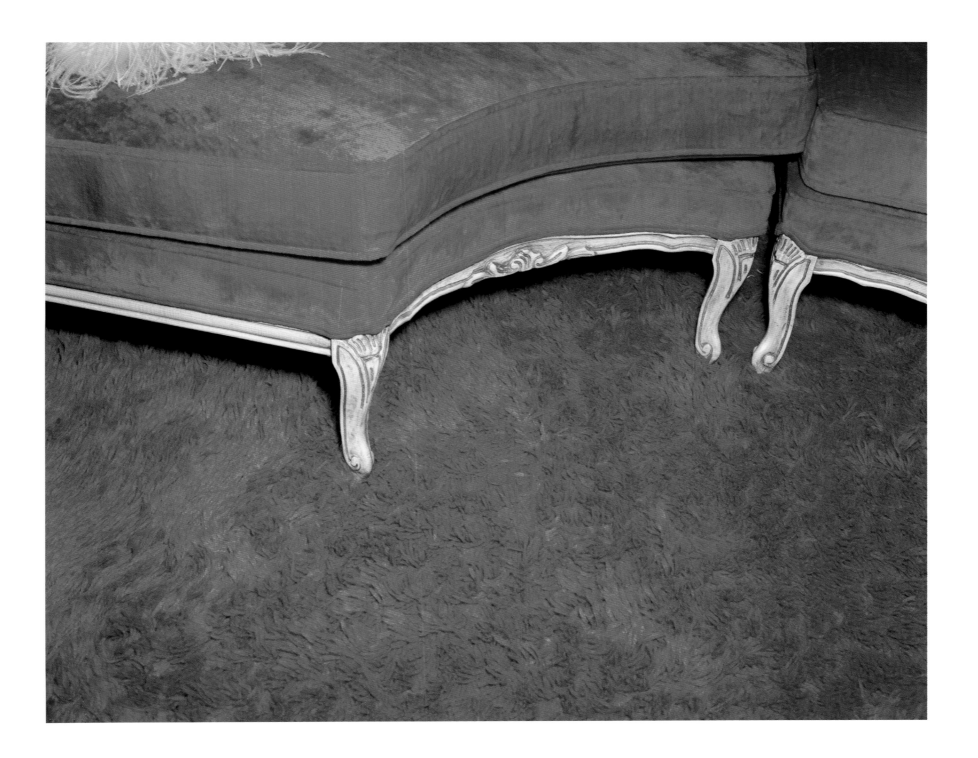

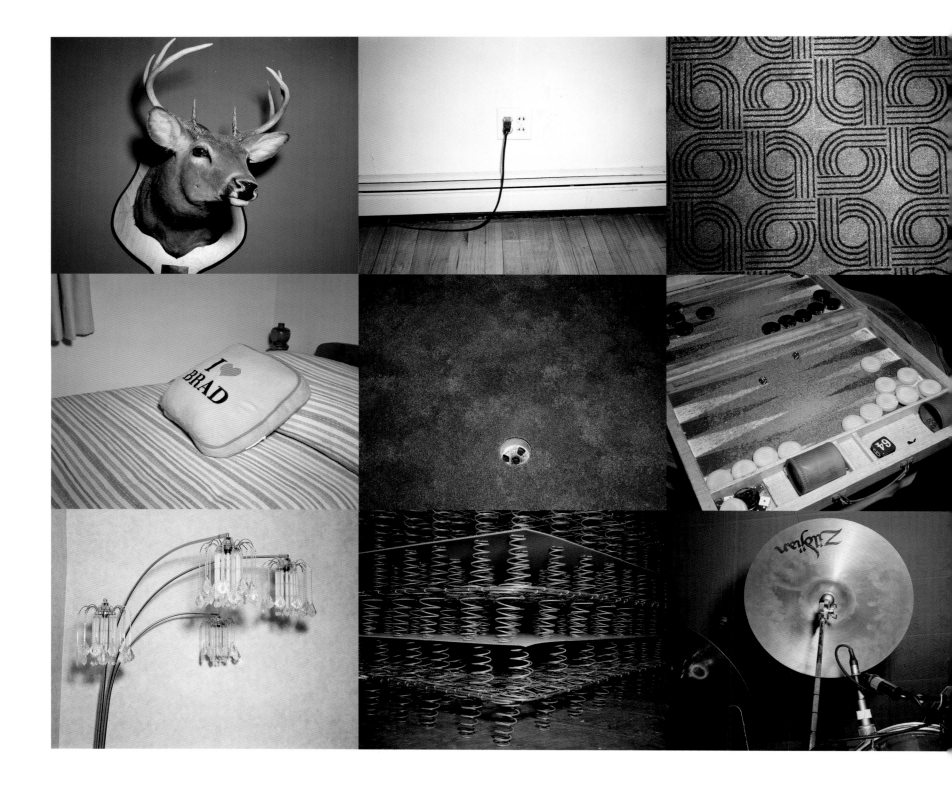

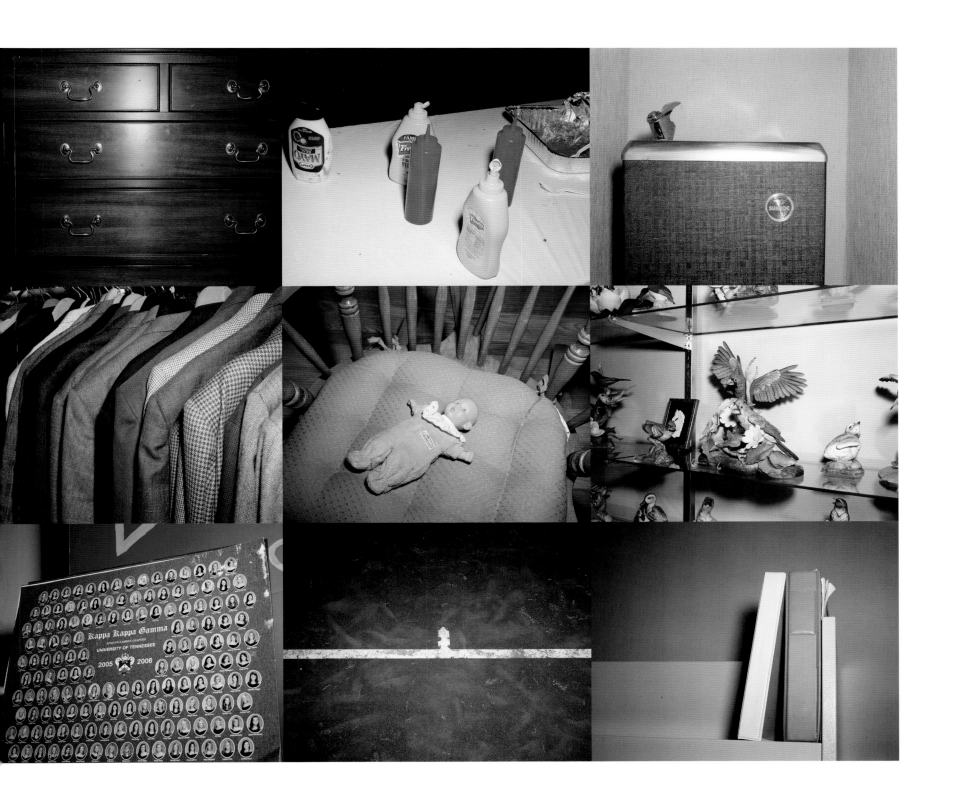

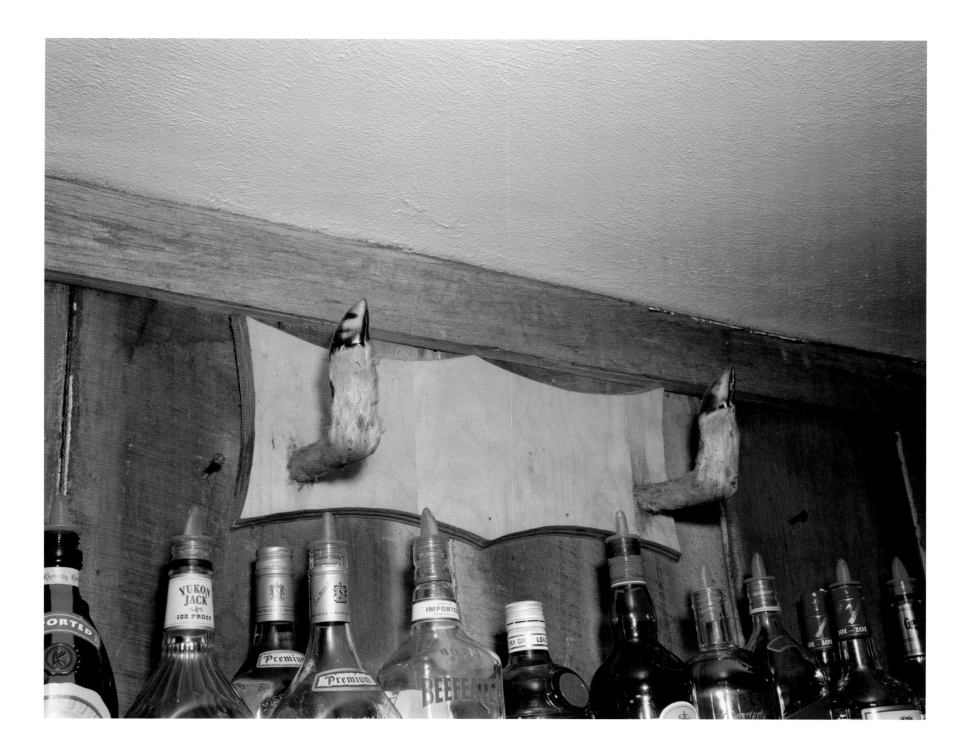

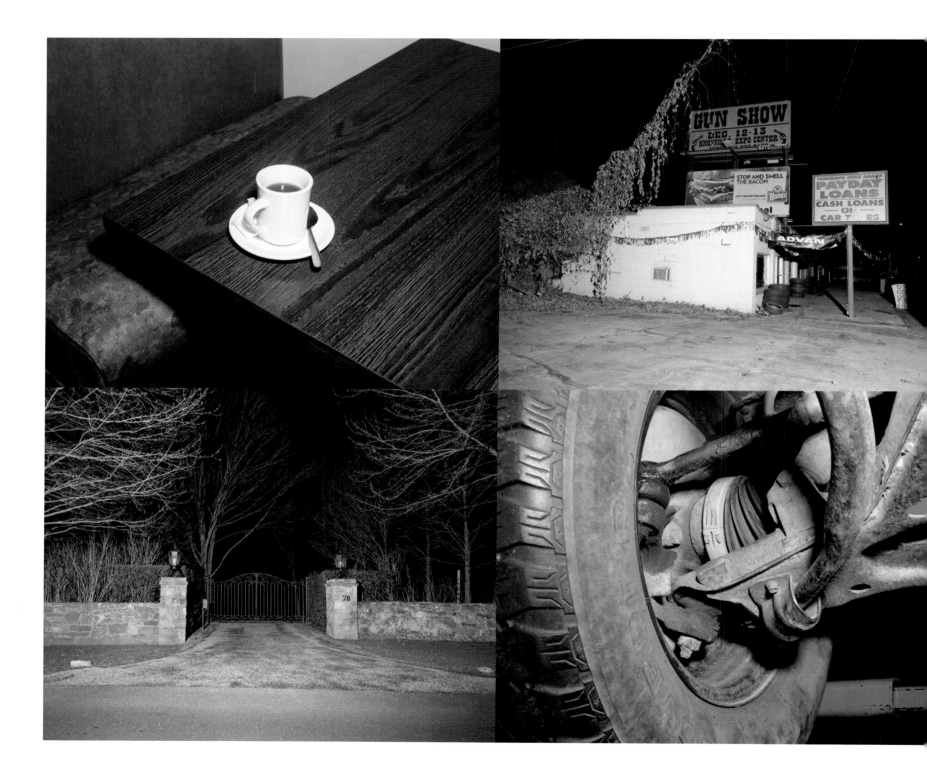

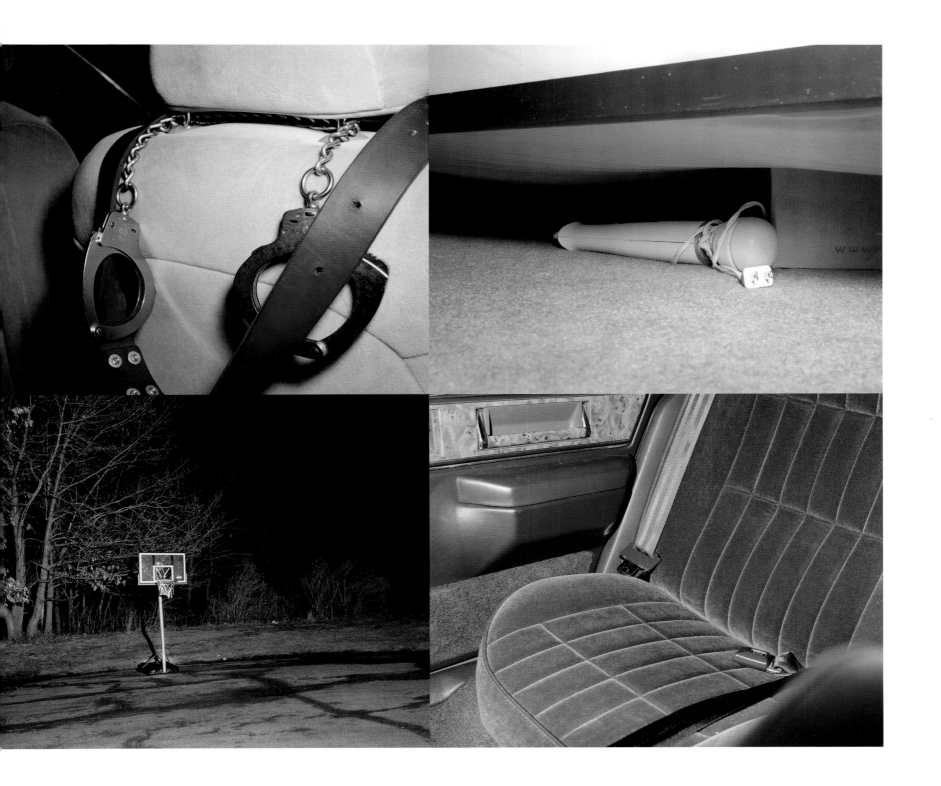

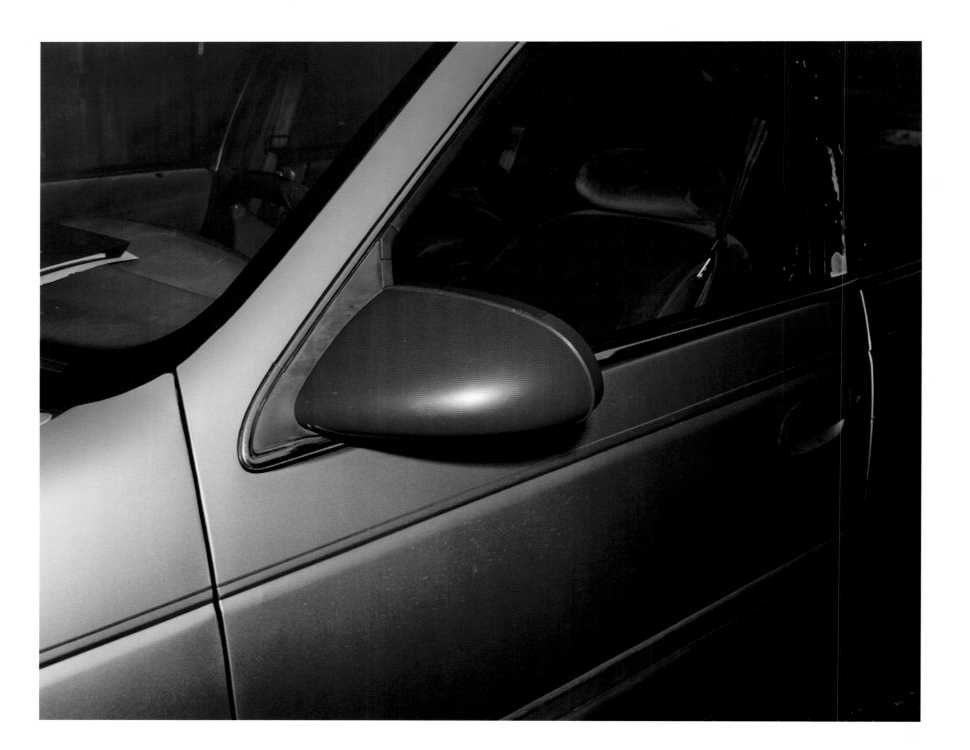

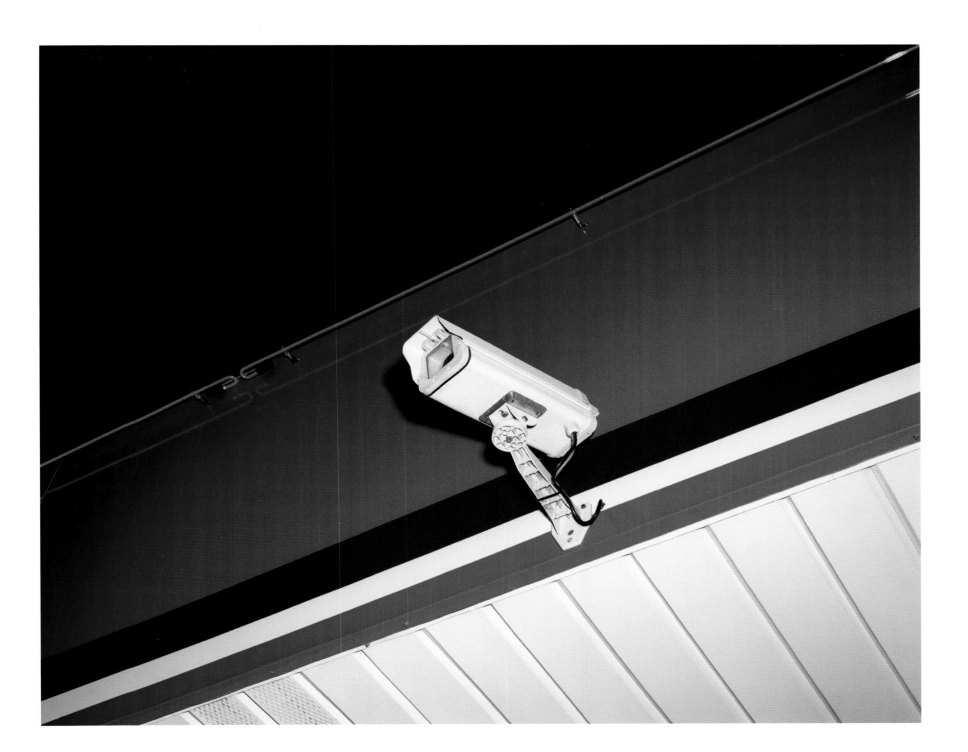

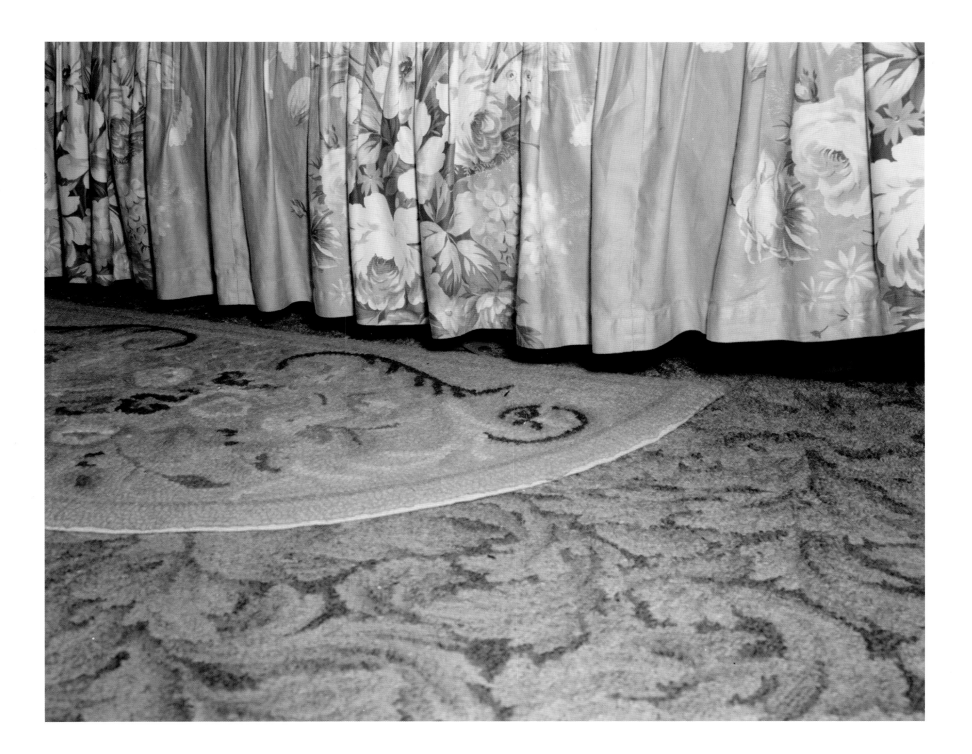

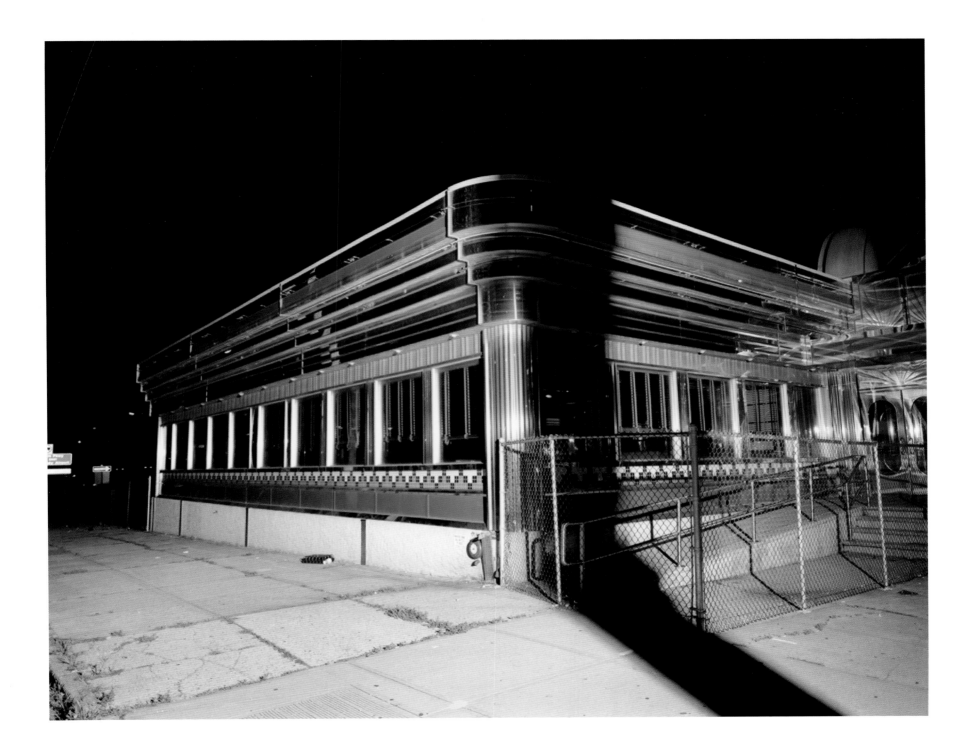

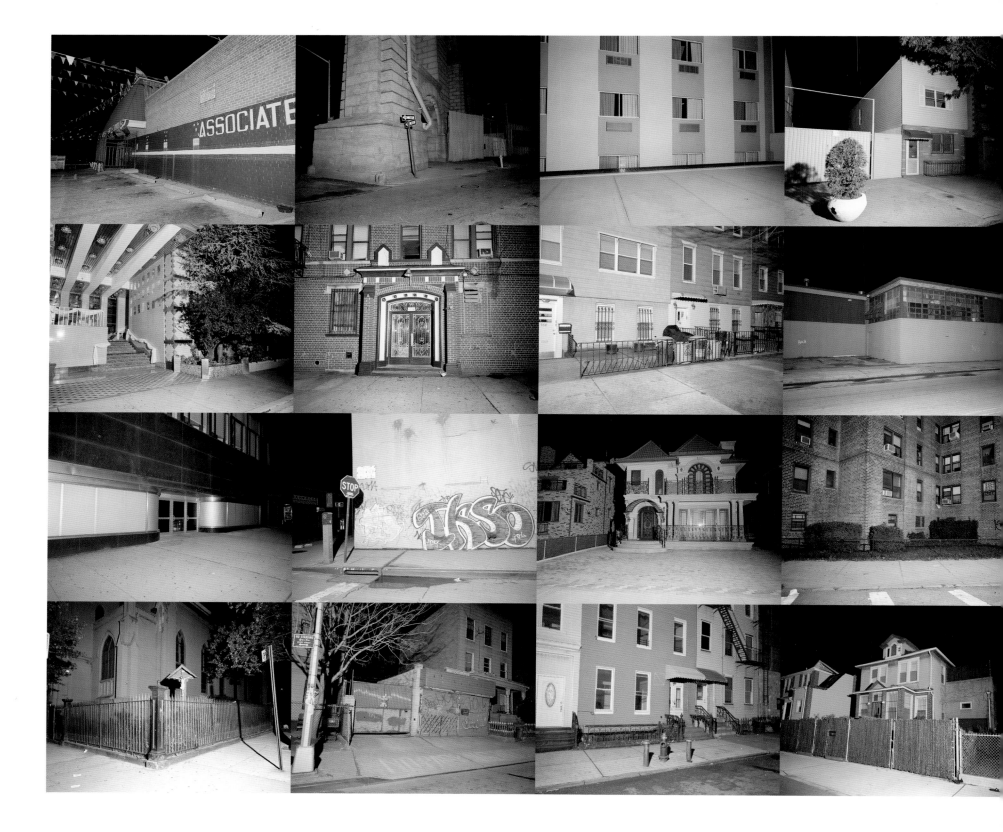

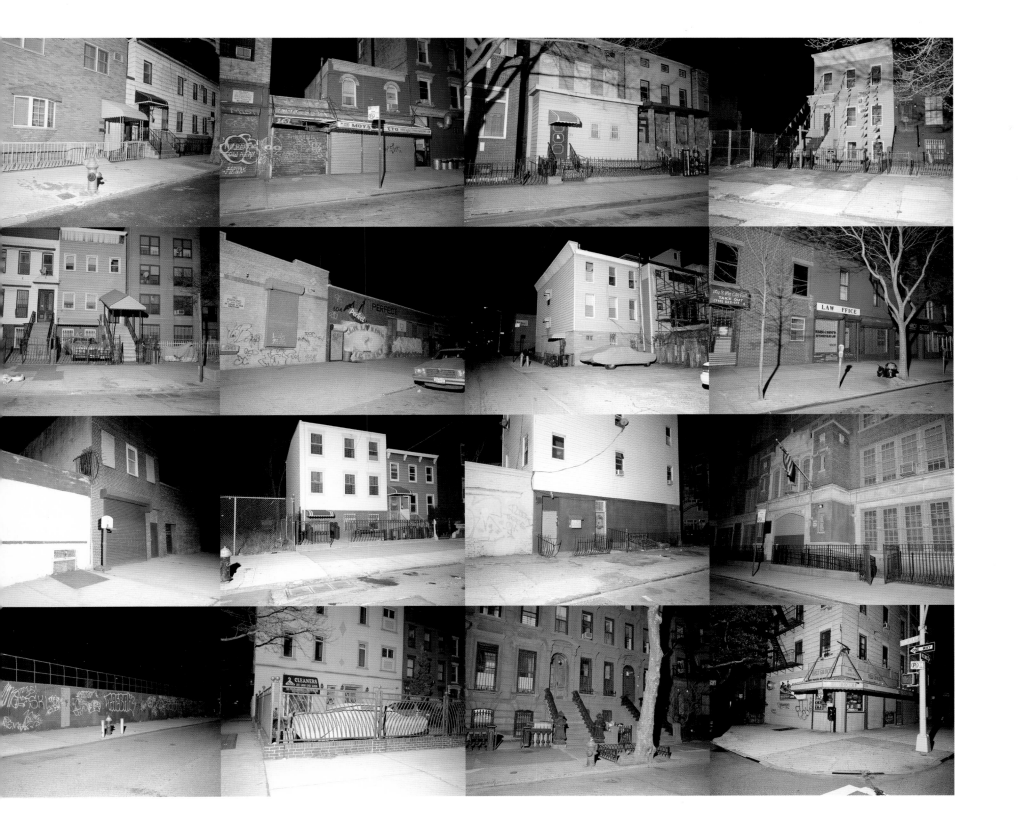

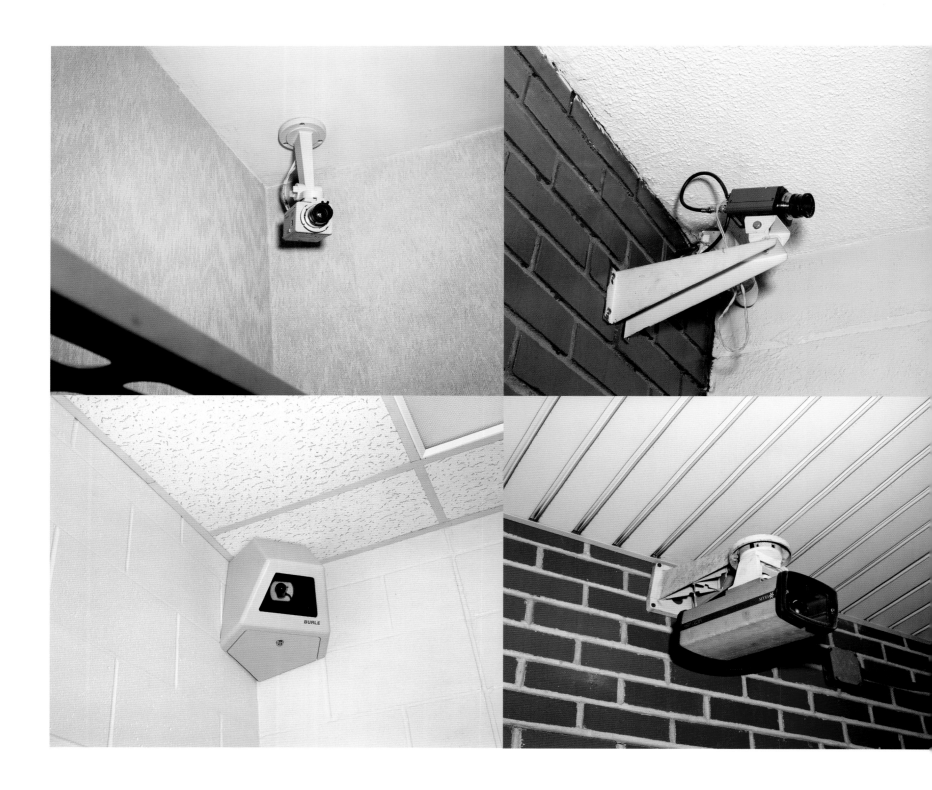

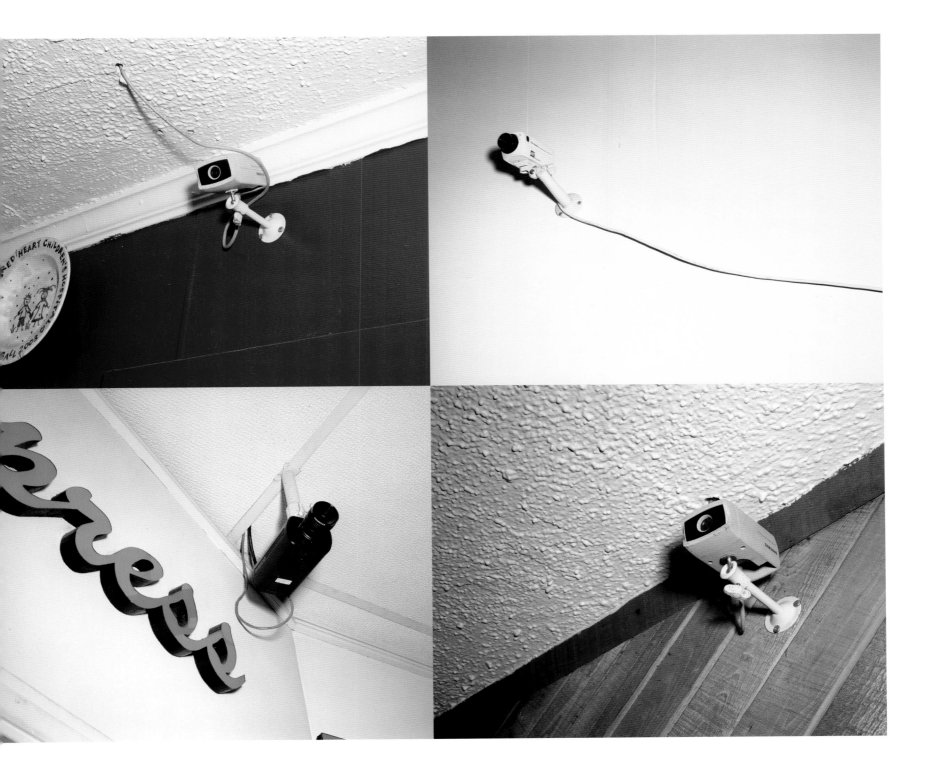

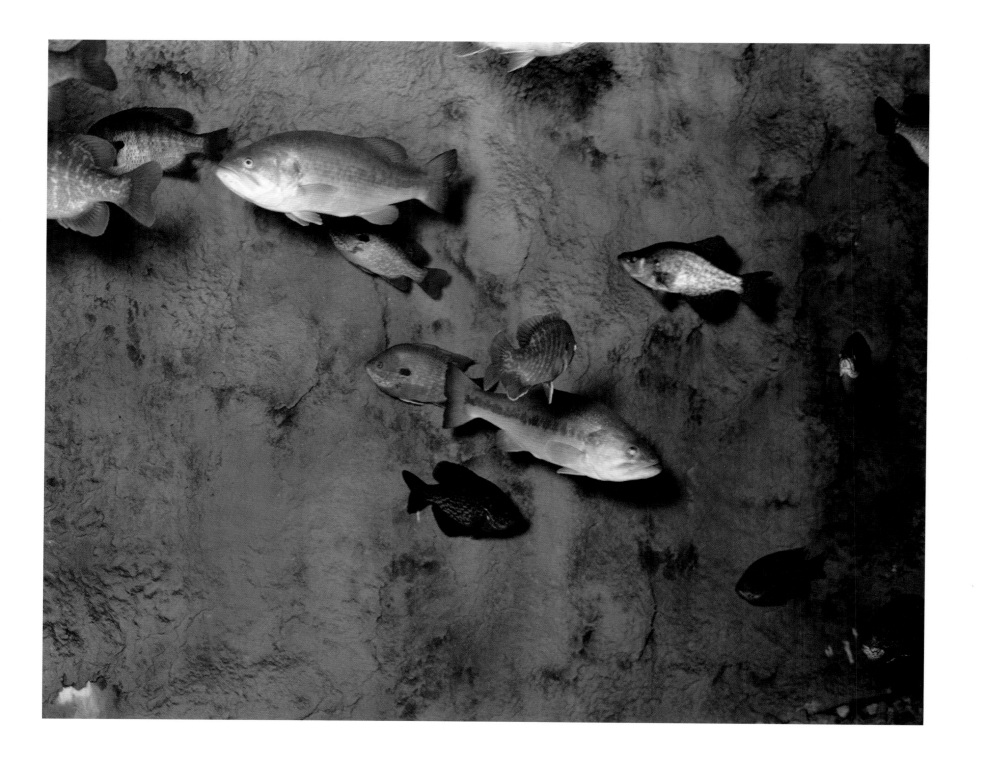

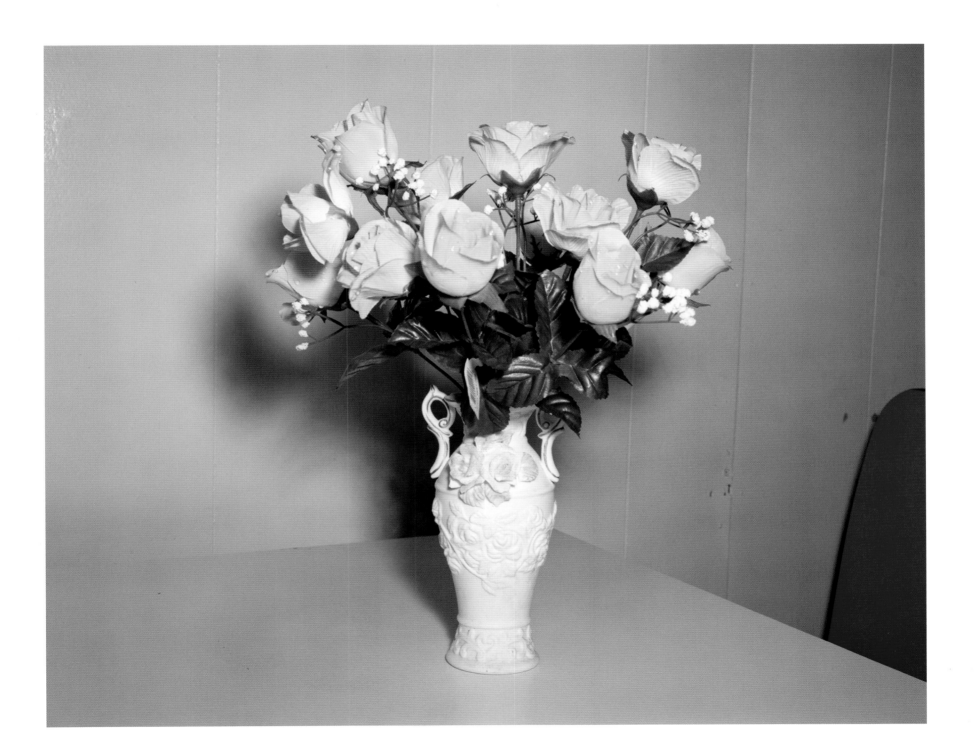

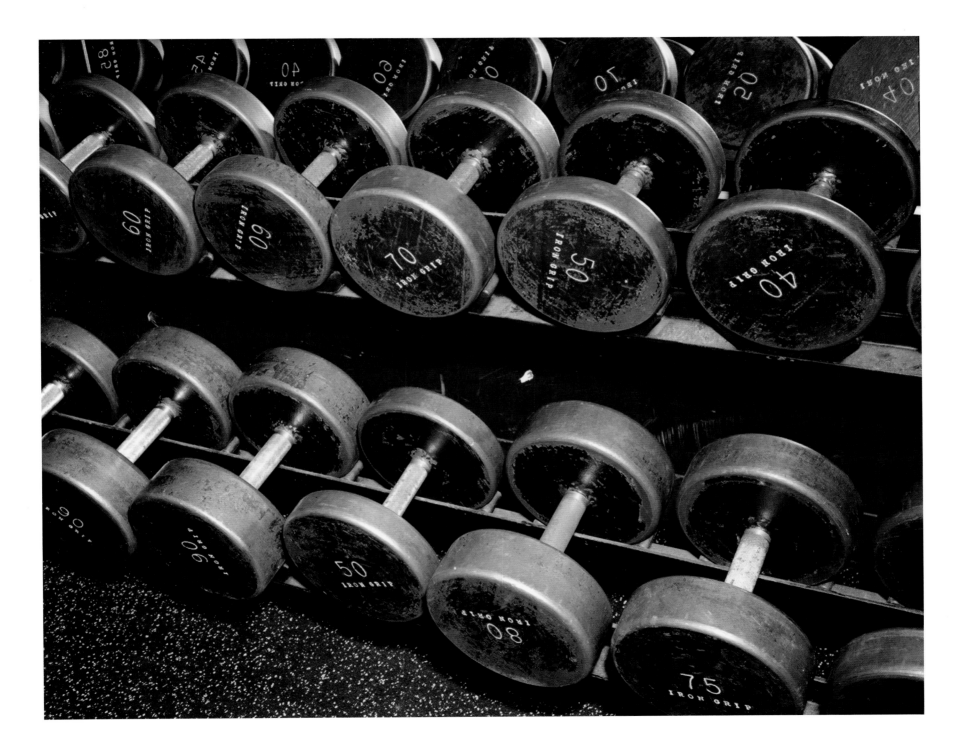

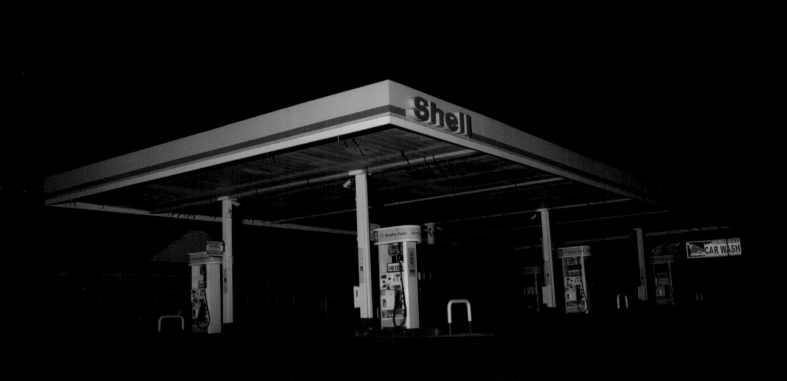

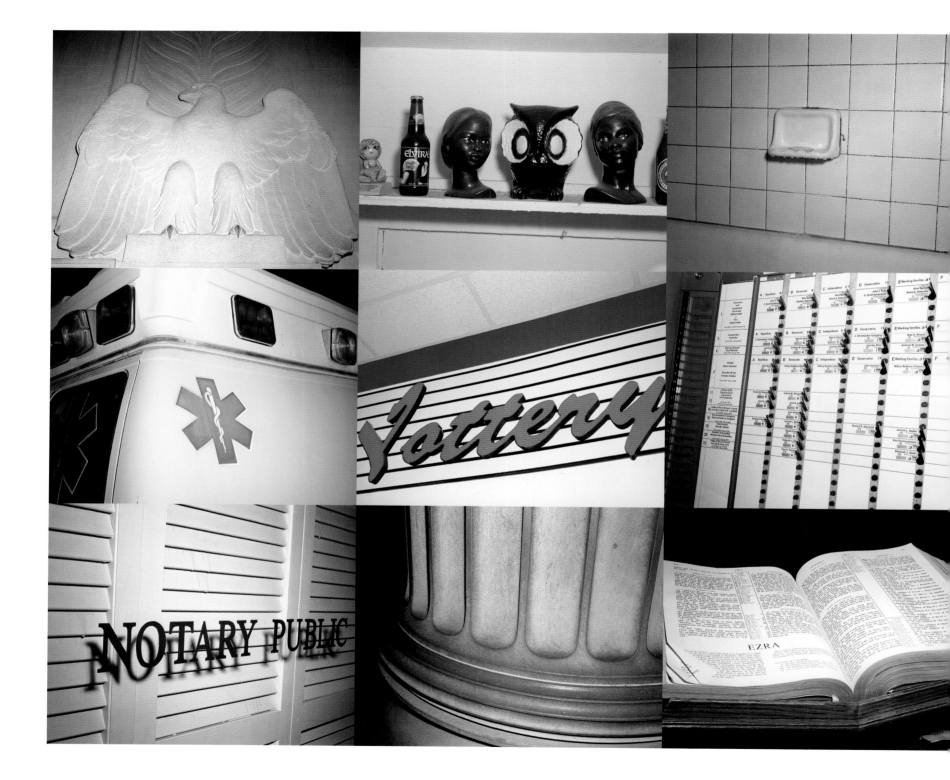

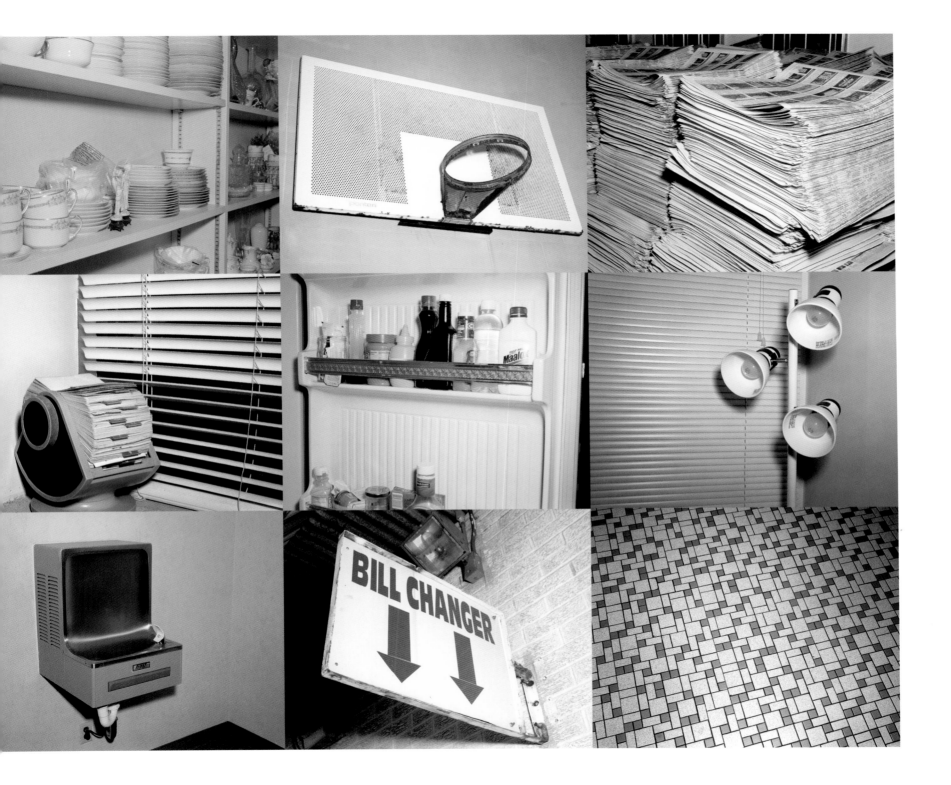

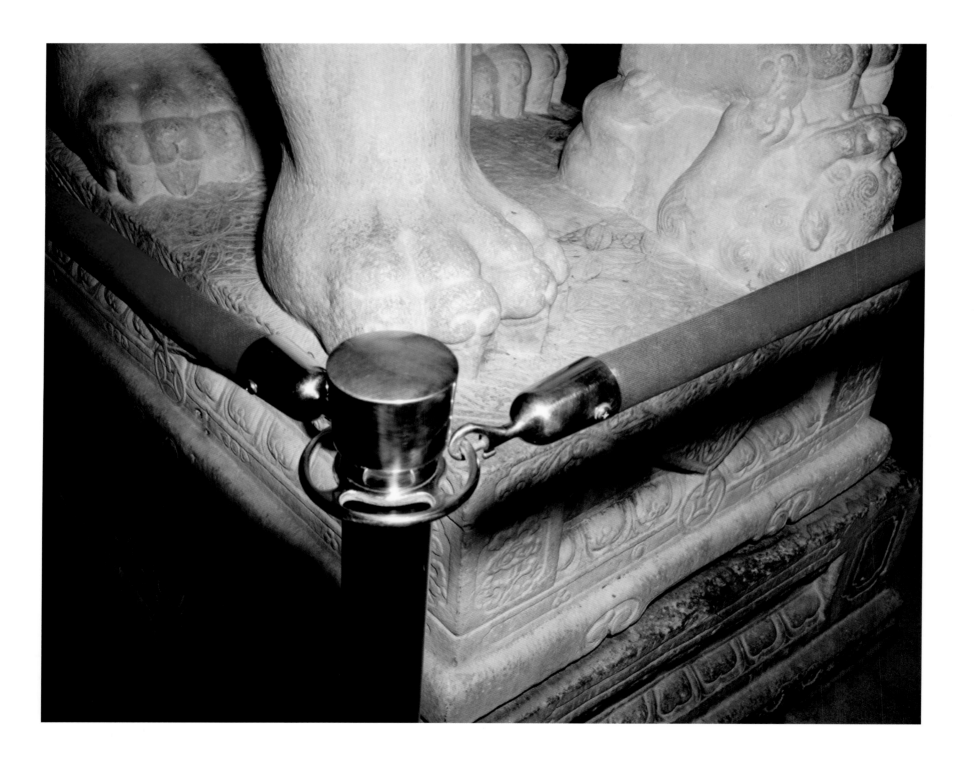

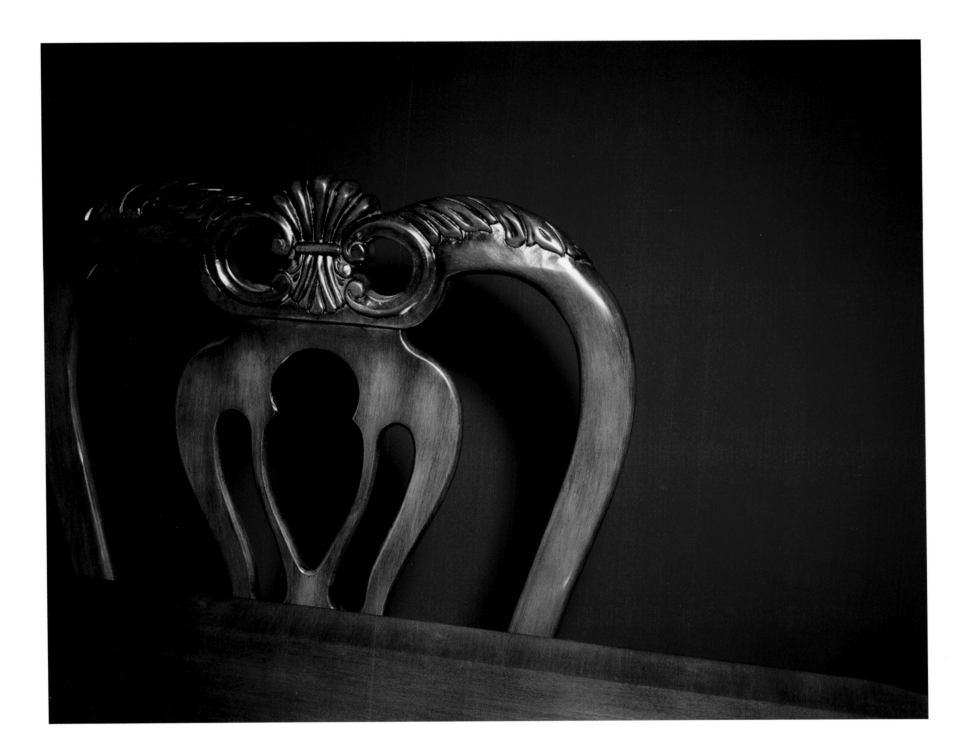

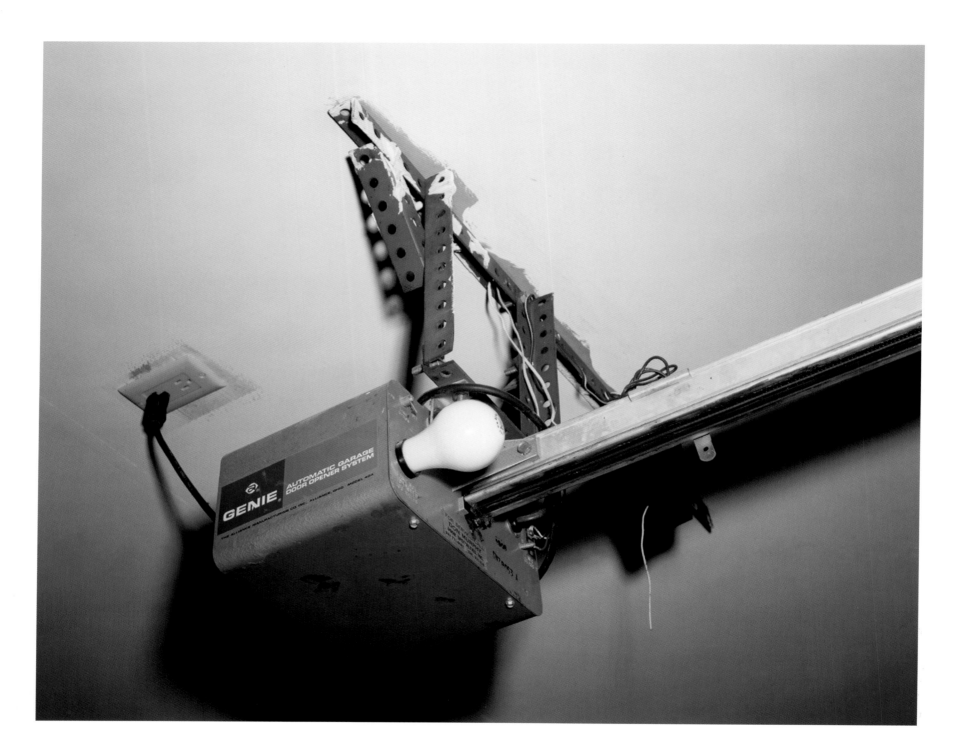

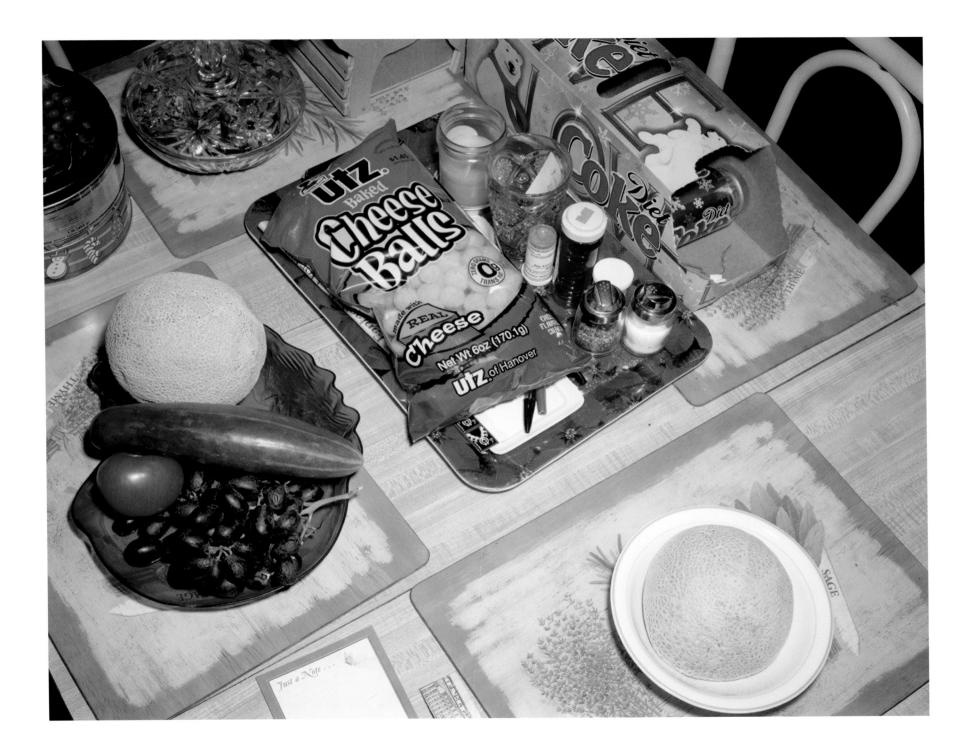

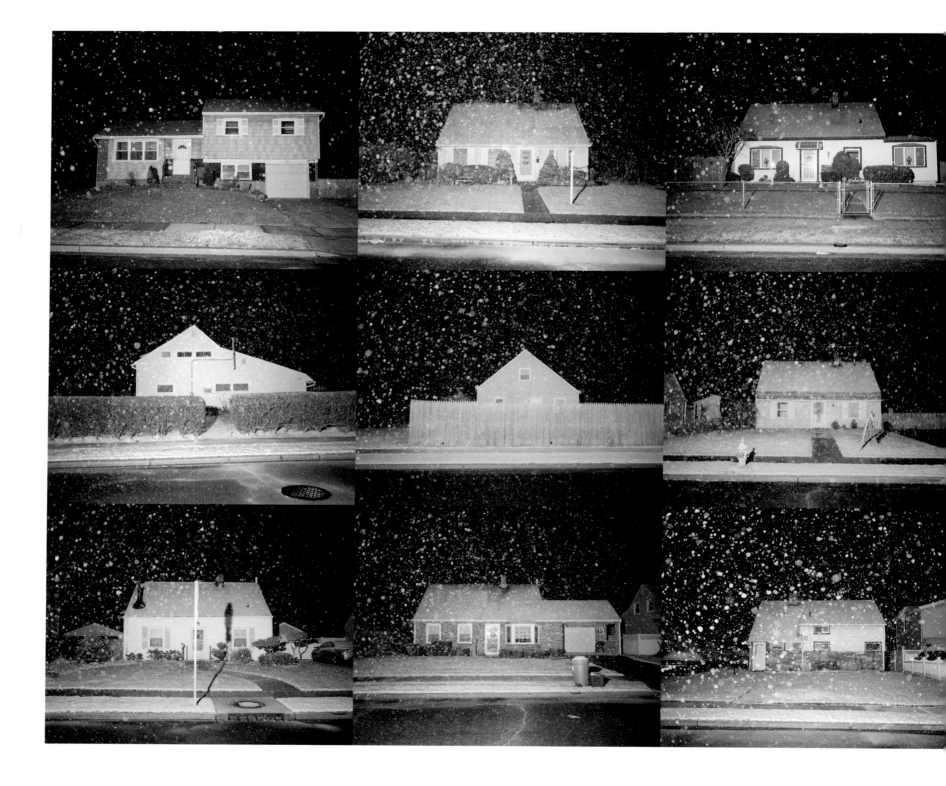

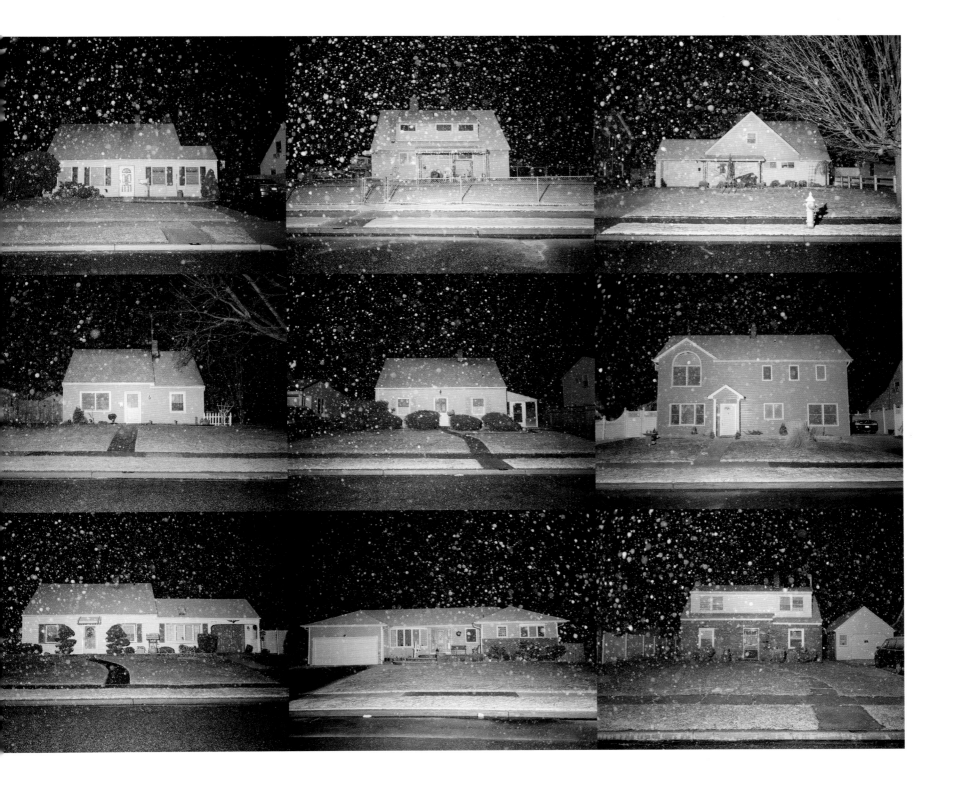

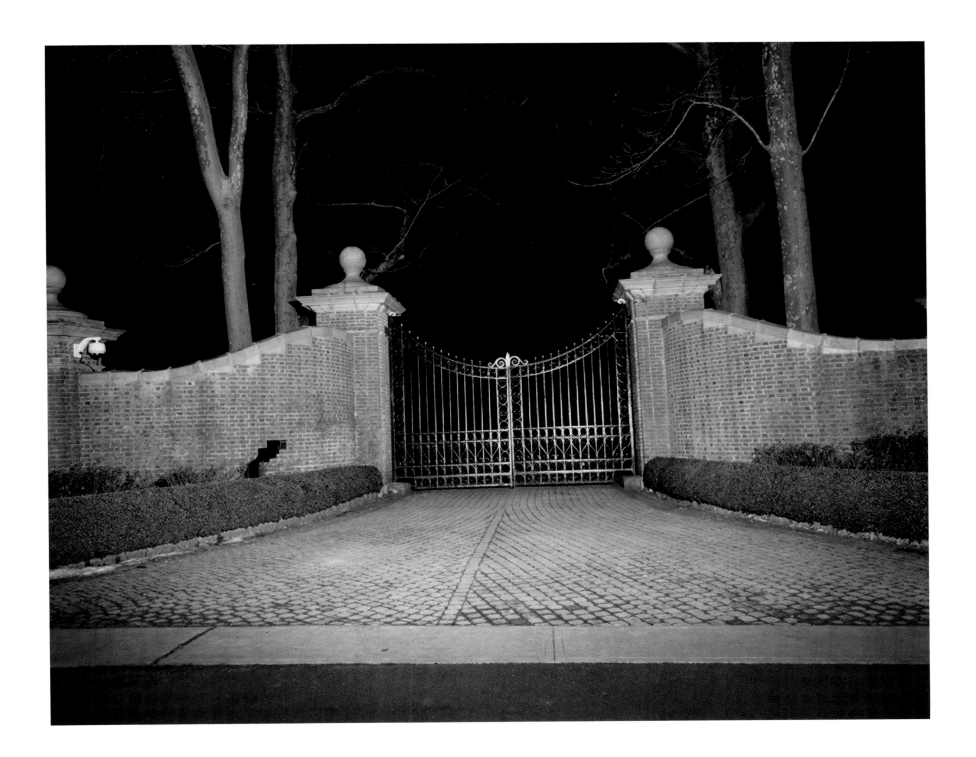

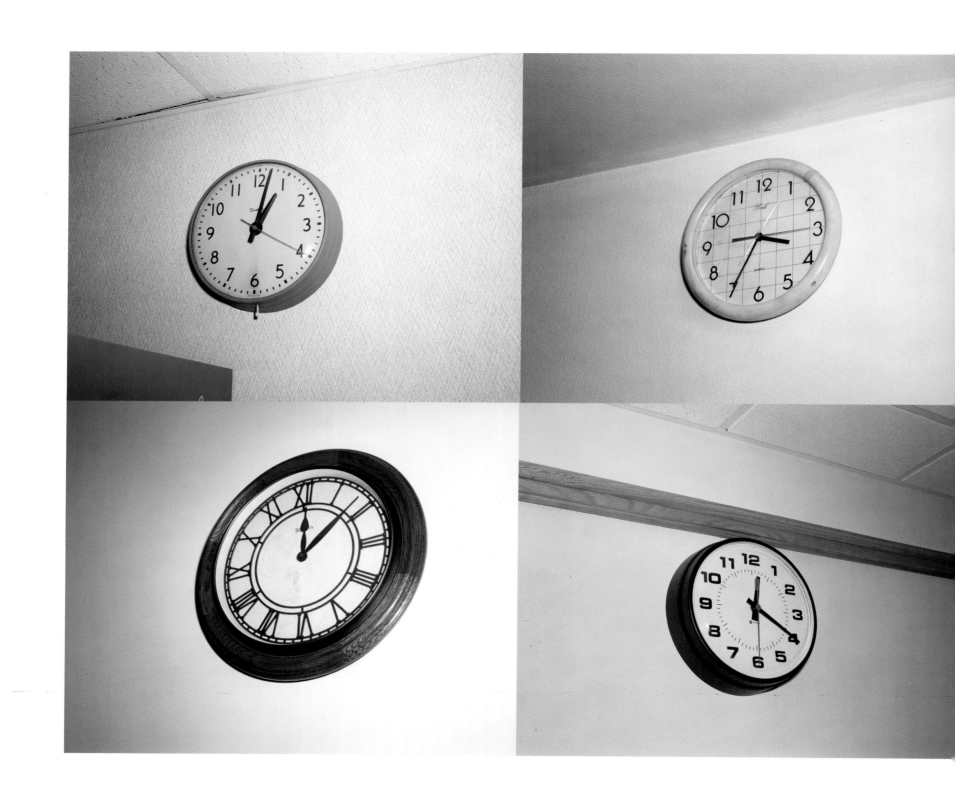

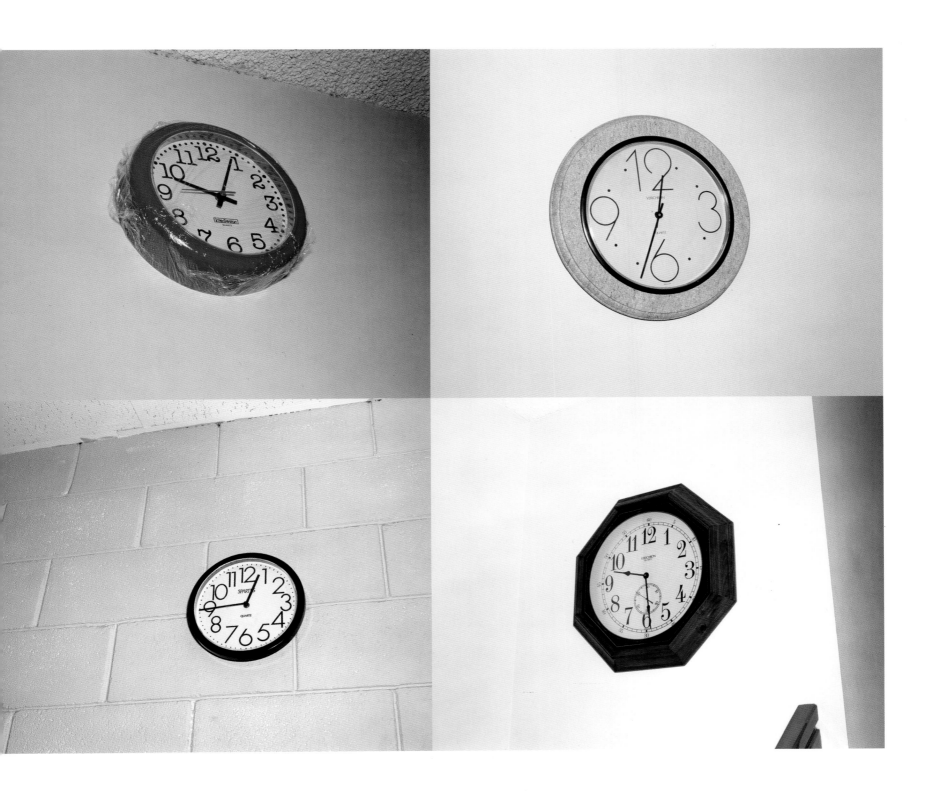

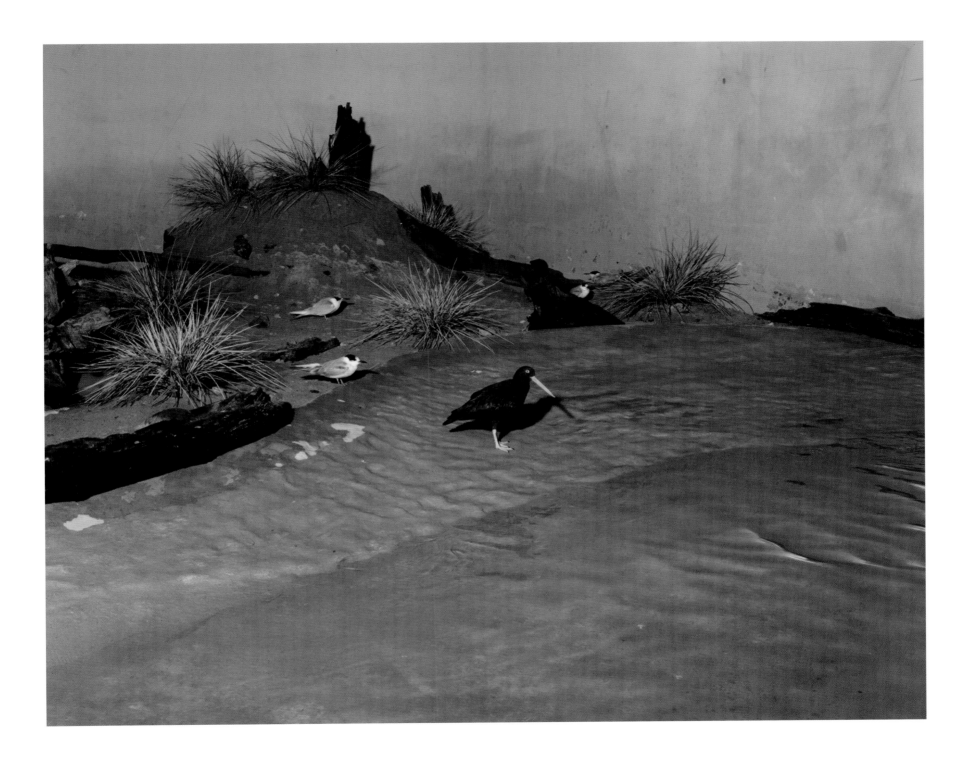

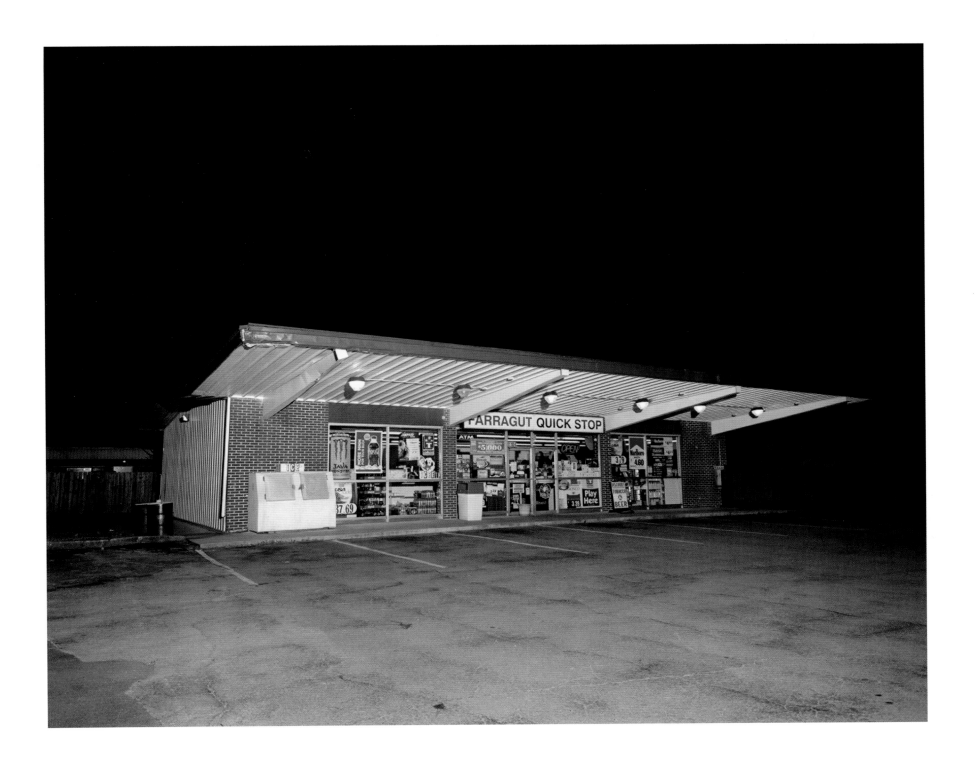

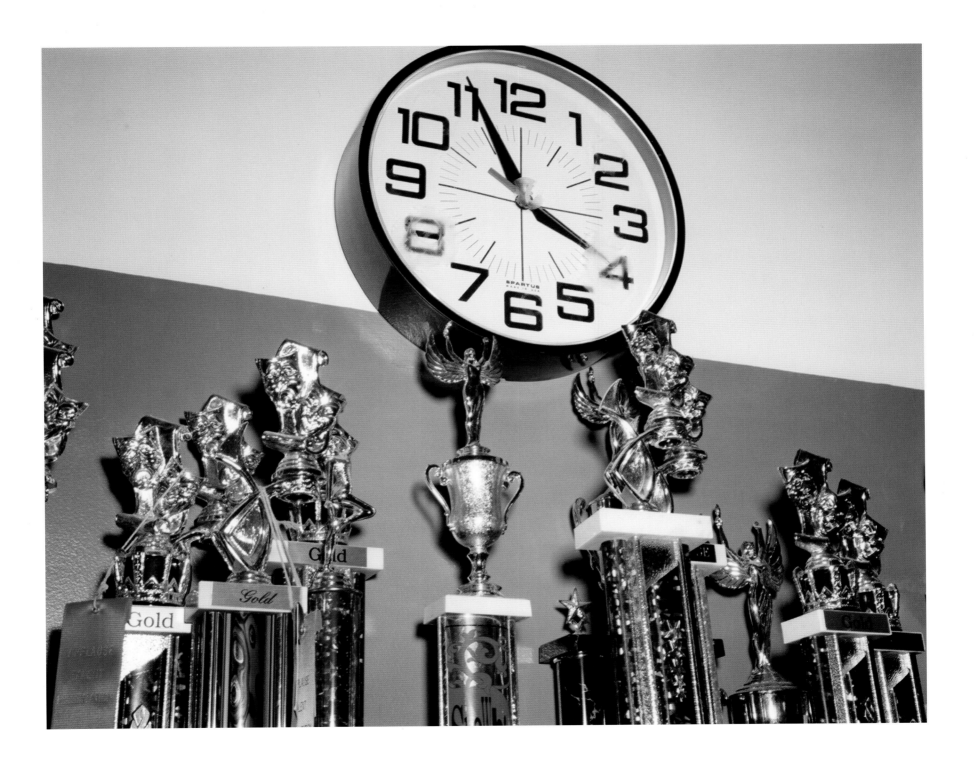